MASTERPIECES *of* PAINTING *in the* J. PAUL GETTY MUSEUM

MASTERPIECES *of* PAINTING *in the* J. PAUL GETTY MUSEUM

THIRD EDITION

BURTON B. FREDERICKSEN

WITH ADDITIONAL TEXT BY

DAVID JAFFÉ

DENISE ALLEN, DAWSON W. CARR, AND PERRIN STEIN

THE J. PAUL GETTY MUSEUM · MALIBU · CALIFORNIA

Christopher Hudson, Publisher
Mark Greenberg, Managing Editor

©1980, 1988, 1995 J. Paul Getty Museum
Published 1980. Revised editions 1988, 1995.

J. Paul Getty Museum
17985 Pacific Coast Highway
Malibu, California 90265

Library of Congress Cataloging-in-Publication Data
J. Paul Getty Museum.
 Masterpieces of painting in the J. Paul Getty Museum / Burton B.
Fredericksen, with additional text by David Jaffé, Denise Allen,
Dawson W. Carr, Perrin Stein.
 p. cm.
 Rev. and enl. ed. of: Masterpieces of painting in the J. Paul
Getty Museum / Burton B. Fredericksen. Rev. ed. 1988.
 Includes index.
 ISBN 0-89236-326-6
 1. J. Paul Getty Museum—Catalogs. 2. Painting—California—
Malibu—Catalogs. I. Fredericksen, Burton B. II. Jaffé, David.
III. Allen, Denise. IV. Carr, Dawson W. (Dawson William), 1951– .
V. Stein, Perrin. VI. Title.
N582.M25A63 1995
750'.74'79493—dc20 94-24057
 CIP

On the front cover:
Canaletto (Giovanni Antonio Canal)
*View of the Grand Canal: Santa Maria della Salute and
the Dogana from Campo Santa Maria Zobenigo* [detail] (no. 14)

On the back cover:
Vincent van Gogh
Irises (no. 30)

Printed in the United States of America

CONTENTS

FOREWORD

Turning the pages of this book gives all of us who work at the Getty Museum a particular feeling of exhilaration. This is a young institution with a daunting job, to build important collections in a time of dwindling supply. This survey of our finest paintings gives a measure of our progress in the last decade, for the reader who cracks the code of accession numbers will discover how many of the works have been acquired recently.

J. Paul Getty had a puzzling attitude toward European paintings, buying works from the late Middle Ages to around 1900 with only fitful enthusiasm. Not until after his death, when the Museum received the benefit of his generous legacy, could the paintings collection be greatly strengthened. As the Museum's Curator of Paintings between 1965 and 1984, Burton Fredericksen brought a new level of professionalism to collecting, exhibiting, and publishing. His work has spanned several eras, beginning at Mr. Getty's modest house-museum in the 1960s, continuing through the construction in 1968–1974 of the present Museum and into the present period of diversification by the Getty Trust and of growth for the Museum. He was followed as Curator of Paintings by Myron Laskin, who served from 1984–1989, and George Goldner, who held the position from 1989–1993.

Since the last edition of this book in 1988, many paintings have been acquired. A representative sampling of those have been treated by the staff of our Department of Paintings: David Jaffé, Curator of Paintings, Dawson W. Carr, Associate Curator, Denise Allen, Assistant Curator, and Perrin Stein, former Assistant Curator.

At the time of the publication of this volume, a new museum building is being constructed in west Los Angeles, where our public will be able to enjoy the paintings collection in beautiful galleries filled with natural light. We look forward to this new era in the history of the Getty Museum and to the updating of this volume many more times.

John Walsh
Director

This is the third book to concentrate on the most prized paintings in the J. Paul Getty Museum. An earlier selection of fifty-one paintings was published in 1980, just as the influence of Mr. Getty's magnificent endowment was beginning to be felt; all but a few of the pictures included at that time had been purchased within the preceding decade. A revised version, containing only thirteen of the paintings previously illustrated, indicating the number of significant acquisitions that had been made by the Museum's Department of Paintings since 1981, was published in 1988. The present volume adds twenty paintings and removes nineteen previously illustrated works.

In light of the considerable refinement and expansion that the paintings collection has undergone within a relatively short span of time, it is worth recalling its history. Mr. Getty did not actively begin to collect until the 1930s, and from the start he gave most of his attention to the French decorative arts. He acquired paintings almost casually, with the intention of displaying them in his home. He disliked competing with museums for pictures, and he reasoned that a major item of French decorative art could be purchased for a fraction of the cost of a comparable painting. He did not, in fact, consider himself to be a collector of paintings. Despite this, he came to purchase two major works, as well as a number of lesser paintings, early in his collecting career. The first picture of importance to enter his collection was Gainsborough's *Portrait of James Christie* (no. 44), purchased in London in 1938. Shortly after, he bought Rembrandt's *Portrait of Marten Looten* (later donated to the Los Angeles County Museum of Art), perhaps the most important painting he was ever to acquire.

With the outbreak of World War II, Mr. Getty was temporarily forced to curtail his collecting, and he did not begin again until the 1950s. In 1953 he first opened his collections to the public in four galleries located in a ranch house behind the present museum building. Although the strengths of the Museum remained in the decorative arts and, later, in Greek and Roman antiquities, he nevertheless acquired more paintings during the 1950s and 1960s. Among them were two very important works, Rembrandt's *Saint Bartholomew* (no. 25) and Veronese's stunning *Portrait of a Man* (no. 12).

In the late 1960s Mr. Getty made the decision to construct a new Museum building in Malibu, modeled after the Villa dei Papiri in Herculaneum, which had been buried by the eruption of Mount Vesuvius in A.D. 79. Many paintings were added to the collection at this time, and its scope was broadened considerably to include areas not previously represented, such as works from the French, early Flemish, and fourteenth-century Italian schools. Despite the growth of the Museum and the addition of a small professional staff, the collec-

tion retained the stamp of its founder, who personally approved each purchase; he demonstrated a marked preference for large paintings with secular and mythological themes. Among the most significant of the pictures acquired between 1969 and 1972 was Georges de La Tour's powerful *Beggars' Brawl* (no. 31).

By the time the new building was opened to the public in 1974, all three of the Museum's collections—decorative arts, antiquities, and paintings—had been considerably expanded. The paintings collection, however, remained the least developed. During the next two years, acquisitions continued at a slower rate, and the Museum's focus became research and catalogue preparation.

After Mr. Getty's death in 1976, it was learned that the bulk of his estate had been left to the Museum and that an expansion of the collections far surpassing anything yet witnessed would be possible. From 1977 to 1979, when funds began to become available, some of the Museum's most significant works by early Italian Renaissance artists were obtained, including paintings by Gentile da Fabriano (no. 2), Masaccio (no. 3), and Carpaccio (no. 4).

With the settling of the estate in 1981 and the institution of a carefully considered acquisitions policy, a new phase of collecting began, and emphasis was given to improving the paintings collection. A series of outstanding pictures was acquired, beginning with *The Holy Family* by Poussin (no. 32). Also included in this group were the first major works by Impressionist artists, as well as Dutch landscapes and genre pieces.

To form a comprehensive collection of great paintings is no longer possible today because of the diminishing numbers available and the escalation of prices. The cost of a single major work now may sometimes exceed that of an entire collection only a decade ago. Nonetheless, through carefully considered additions, the Museum's collection continues to take on more depth, variety, and quality. We trust that visitors to the Museum will find the paintings galleries rewarding and worthy of repeated visits and that the present selection of masterpieces will prove to be just one of a series documenting the growth and improvement of the collection.

Burton B. Fredericksen
Senior Curator for Research

SIMONE MARTINI

ITALIAN, circa 1284–1344

Saint Luke, 1330

TEMPERA ON PANEL

67.5 × 48.3 cm (26 ⁹/₁₆ × 19 in.)

82.PB.72

A bastion of conservatism, fourteenth-century Siena was not immediately affected by the progressive currents that the Renaissance brought to Florence and parts of northern Italy. The adherence to a more orthodox, and therefore less experimental, tradition allowed local artists to maintain and perfect particularly high standards of craftsmanship. During the first half of the fourteenth century, however, a number of Sienese artists did begin to soften the rigidity of the local Byzantine-influenced style. Simone Martini was perhaps the most accomplished of this group. In his hands the figure became more elegant and graceful, and the long-established stylizations of his predecessors began to give way to a greater awareness of the human form and its potential for beauty. Simone often worked for patrons in cities such as Avignon in France that were considerably removed from his birthplace. The poems that Petrarch wrote in his praise spread his reputation and that of the Sienese school beyond the borders of Italy.

The Museum's panel depicts Saint Luke, who is identified by the inscription s.LVC[A]s *EVLˢTA* (Saint Luke the Evangelist). A winged ox, the saint's symbol, holds his inkpot as he writes his Gospel. This painting is in nearly perfect condition and retains its original frame. It was probably the right-hand panel of a five-part portable polyptych, or multipart altarpiece. The remaining four sections (three of which are in the Metropolitan Museum of Art, New York, and the fourth of which is in a private collection in New York) depict the Madonna (the central panel) and three other saints. The panels were probably hinged together with leather straps so that the altarpiece could be folded and carried. Holes in the top of the frame indicate that there may have been attachable pinnacles, perhaps with angels. The fully expanded altar would have been almost seven feet in width. It has recently been suggested that the altarpiece was originally painted for the chapel in Siena's Palazzo Pubblico.

Portions of some of the panels were painted by the artist's assistants, but the Getty Museum's panel was executed entirely by Simone. The refinement of design, extreme elegance of the hand, slightly elongated figure, and intensity of the expression are all hallmarks of his work.

BF

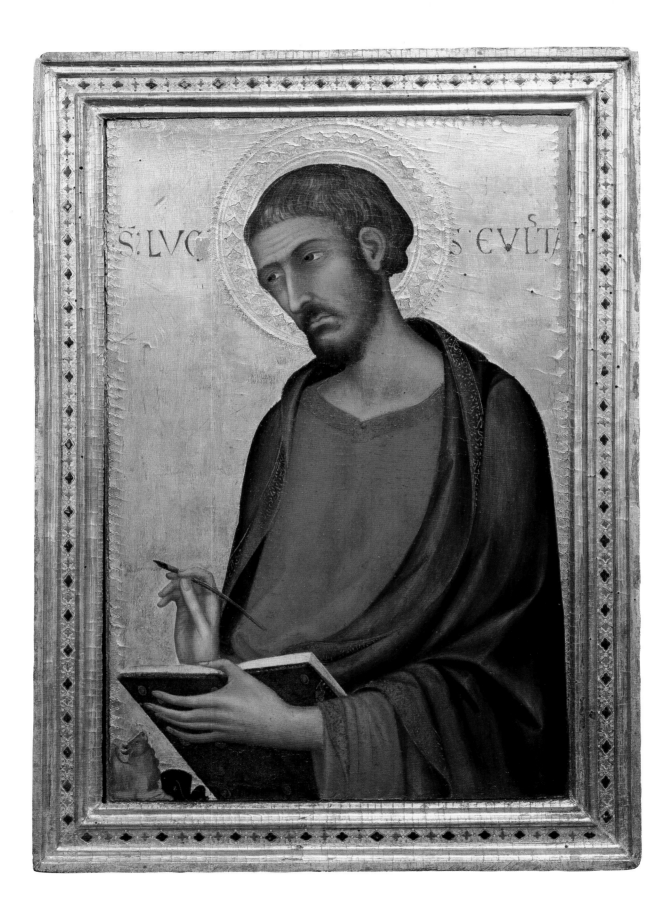

GENTILE DA FABRIANO

ITALIAN, circa 1370–1427
Coronation of the Virgin, circa 1420
TEMPERA ON PANEL
87.5 × 64 cm (34 ½ × 25 ¼ in.)
77.PB.92

A rare surviving example of a processional standard, the *Coronation of the Virgin* was meant to be carried on a pole in religious parades. It is painted in brilliant colors over a layer of gold leaf and must have once had an image of God the Father in a tympanum, a separate section that was attached above; this has since been lost. The standard was also originally double sided and was sawn into two sections sometime prior to 1827. The reverse, the *Stigmatization of Saint Francis*, is now in the Magnani-Rocca collection in Reggio Emilia in northern Italy.

The choice of subjects and the evidence of existing documents indicate that the standard was painted for the Franciscan monks in Fabriano and kept at the church of San Francesco. The painting was moved about to different locations over the course of the next four centuries, as churches were torn down and replaced, but because of its connection with Gentile, the town's most famous son, it was revered in Fabriano long after such paintings ceased to be made. By the 1830s, however, such relics of the late Middle Ages and Renaissance had become highly coveted, and an English collector was able to purchase the *Coronation*.

Gentile is thought to have painted the standard on a visit to his hometown in the spring of 1420, rather late in his illustrious career. By this time he had acquired fame and prestige throughout Italy as the greatest artist of his generation. Although relatively few of his paintings survive, his works had an enormous influence (in part because of their strong sense of space and form) on his contemporaries.

In the Museum's panel, the artist has composed his scene using a number of rich fabrics with large and colorful patterns, a device that did not permit him to develop the spatial aspects of the painting to his usual degree. Christ both blesses and crowns the Virgin, an unusual detail for this time, while to each side the angels sing songs inscribed on scrolls. The total effect is one of luxuriousness and opulence befitting a panel that was once one of the town of Fabriano's most venerated religious treasures.

BF

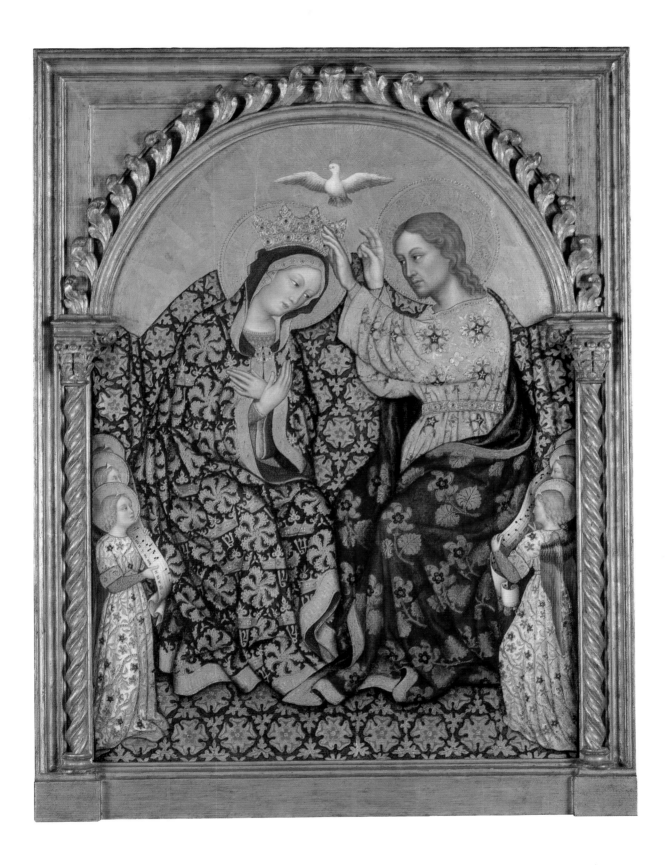

MASACCIO (TOMMASO DI GIOVANNI GUIDI)

ITALIAN, 1401–1428(?)
Saint Andrew, 1426
TEMPERA ON PANEL
52.4 × 32.7 cm (20 ⅝ × 12 ⅝ in.)
79.PB.61

Masaccio's brief but unparalleled career was marked by a few major works, including an altarpiece painted for the church of the Carmine in Pisa; a cycle of frescoes for the Brancacci chapel in the church of the Carmine in Florence; and a fresco depicting the Trinity in the church of Santa Maria Novella in Florence. All were painted within a span of about four years, but the only one of these that is clearly documented from the time is the altarpiece for Pisa, an epochal work that became famous immediately. It is to this altarpiece that the Museum's panel once belonged.

Masaccio, a citizen of Florence, began work on the Pisa altarpiece in February 1426, and he must have spent much of his time in Pisa until its completion the day after Christmas. The chapel in which it was to be placed had been constructed the year before at the request of Ser Giuliano di Colino degli Scarsi, a well-to-do notary in Pisa. The notary's records of payment show that Masaccio used two assistants, his younger brother Giovanni and Andrea di Giusto, both of whom later became respected artists in their own right.

The central part of the altarpiece, now in the National Gallery, London, depicts the Madonna and Child with angels singing and playing instruments. At the sides were panels of Saints Peter, John the Baptist, Julian, and Nicholas (now presumed lost). In the predella, the platform or base under the altarpiece, were stories from the lives of these saints and the *Adoration of the Magi* (all of which are now in the Staatliche Museen Preussischer Kulturbesitz, Berlin). Above the Madonna was the *Crucifixion* (most probably the painting now in the Museo e Gallerie Nazionali di Capodimonte, Naples), and on either side in the upper register were many other saints. The Getty panel of Saint Andrew is presumed to have been one of these. The entire altarpiece was about fifteen feet tall, a large and imposing construction.

The value of Masaccio's work lies in its innovative rendering of the figure and its very original understanding of form and volume, both of which are seen in the monumentality and solidity of the figure of Saint Andrew. The artist is given credit for having begun an entirely new phase in the history of painting and for being the first since classical times to project a rationally ordered illusion of space onto a two-dimensional surface. As much as any other painting, this altarpiece marks the beginning of the period known as the Renaissance in fifteenth-century Tuscany.

BF

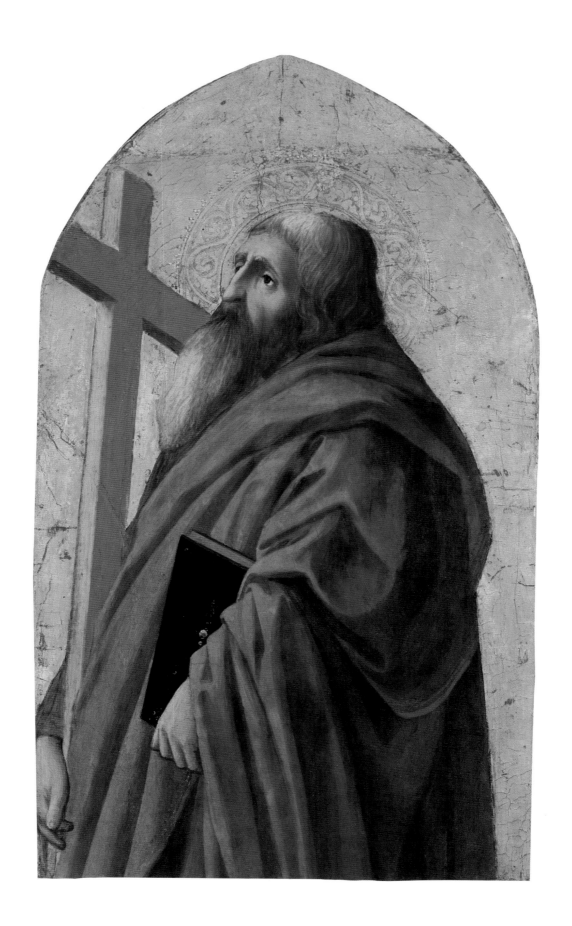

VITTORE CARPACCIO

4

ITALIAN, 1455/56–1525/26
Hunting on the Lagoon, circa 1490–1496
OIL ON PANEL
75.4 × 63.8 cm (30 × 25 in.)
79.PB.72

Carpaccio was one of the first Renaissance painters to employ scenes of everyday life in his work. This striking view of his native Venice shows cormorant hunters on a lagoon. Note that the hunting party does not use arrows but rather shoots pellets of dried clay, apparently to stun the birds and not damage their flesh or plumage. In an early instance of arrested action in a picture, one such pellet, just fired from the boat at right, can be seen in midair, about to clout the cormorant in the foreground.

This panel is the top part of a composition that was originally much longer, as the truncated lily in the lower left corner suggests. It served as the background for a scene of two women sitting on a balcony overlooking the lagoon, now in the Museo Correr in Venice. That painting has a vase with a stem sitting on a balustrade that matches up with the blossom in our painting. Recent examination of both panels confirmed that they were once one; the wood grain is identical, and much like a fingerprint, wood grain is unique. Sadly, they were probably sawed apart for commercial reasons sometime before the bottom part entered the Museo Correr in the nineteenth century.

The back of the Correr's panel was removed, presumably at the time it was separated from the top, but the reverse of the Museum's painting preserves an extraordinary

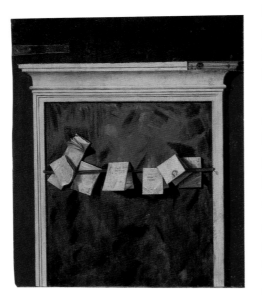

image. The illusionistic letter rack, with letters seemingly projecting into our space, is the earliest known trompe-l'oeil ("fool the eye") painting in Italian art.

The back also has grooves cut for hinges and a latch, indicating that the two-sided panel probably functioned as a decorative window shutter or a door to a cabinet. This suggests that there may have been a matching shutter or door unknown today. If the painting served as a shutter, when closed the panel would have made the spectator think the window was open to this vista of the lagoon, extending the remarkable illusionism even further.

DC

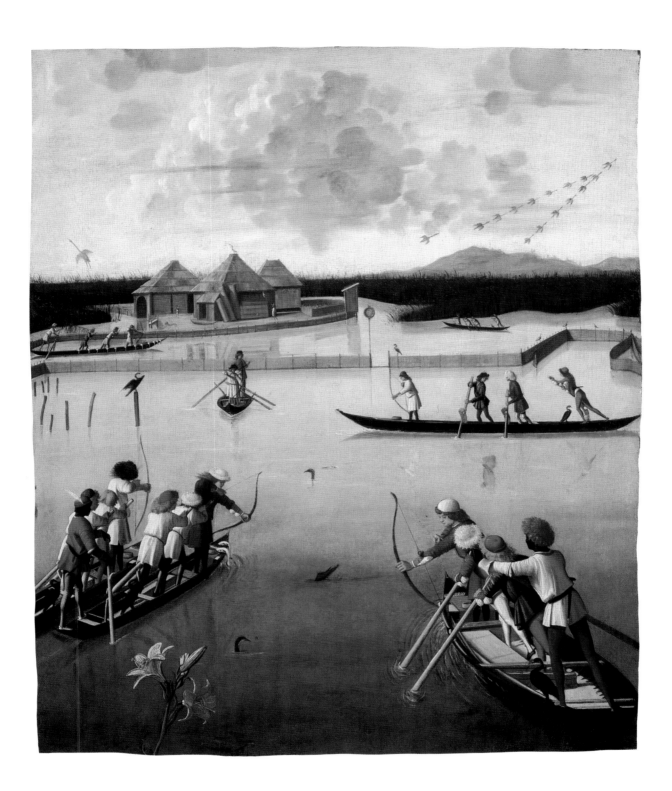

ANDREA MANTEGNA

ITALIAN, circa 1431–1506
The Adoration of the Magi, circa 1495–1505
TEMPERA ON CANVAS
54.6 × 70.7 cm (21 ½ × 27 ⅞ in.)
85.PA.417

The Renaissance was characterized by an intense reawakening of interest in classical art and civilization. During the fifteenth century, some of the most overt emulation of "classical" style occurred in northern Italy, especially Padua and Mantua. This was primarily due to the influence of Andrea Mantegna, who worked in both cities and spent much of his career in the court of Lodovico Gonzaga, Marquis of Mantua.

Although Mantegna probably had no examples of classical painting for study, he did have access to some sculpture and to recently excavated fragments of Roman figures and reliefs. In his religious pictures, as well as his works with classical or mythological themes, the emphasis on sculptural models is apparent. His style is characterized by sharp definition of figures and objects, combined with a clear articulation of space. Some of his pictures are executed in grisaille, or tones of gray, as if he were imitating reliefs, and they give the impression of having been carefully carved in great detail.

The Museum's canvas was most probably painted in Mantua, very possibly for Lodovico Gonzaga. It has a completely neutral background with no attempt to indicate a setting. Kneeling before the Holy Family are the three kings: the bald Caspar, Melchior, and Balthasar the Moor. The hats worn by Melchior and Balthasar are reasonably accurate representations of oriental or Levantine headgear. Caspar presents a blue-and-white bowl of very fine quality Chinese porcelain (one of the earliest depictions of oriental porcelain in Western art). Melchior holds a censer, which has been identified as Turkish tombac ware, and Balthasar offers a beautiful agate vase. Objects of this sort were not commonly found in Italy, although some of the costume accessories might have been seen in Venice, which maintained an active trade with the East. They may have been gifts from foreign heads of state that formed part of the Gonzaga collections.

The Museum's *Adoration* is one of the few fifteenth-century Italian paintings executed on linen instead of wood. Such pictures were not originally varnished because they were painted in tempera rather than oil. Varnish applied at a later time has darkened the canvas, but the beauty of the figures and the richness of the detail have hardly been affected.

BF

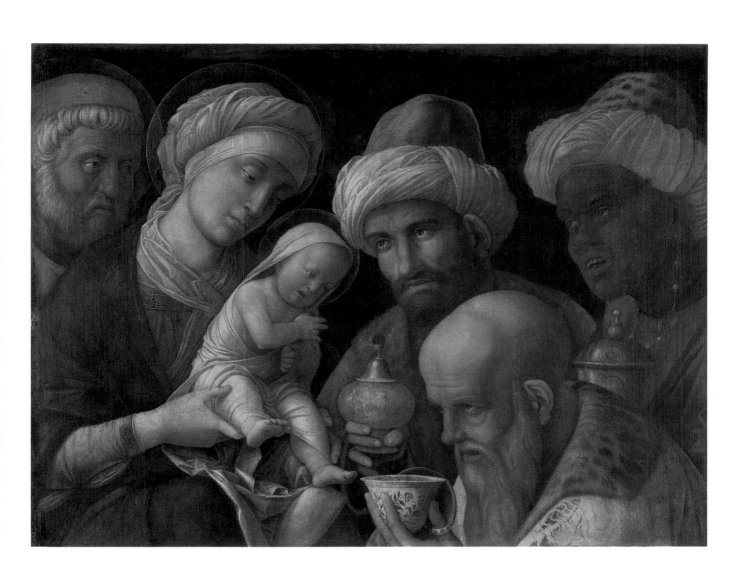

Dosso Dossi (giovanni de' luteri)

Italian, active 1512–died 1542
Mythological Scene, 1520s
OIL ON CANVAS
160 × 132 cm (63 × 52 in.)
83.PA.15

During the early sixteenth century, the ducal court at Ferrara assembled and employed some of the most original and brilliant painters, writers, and musicians of the time. Most of this activity was initiated by Duke Alfonso I d'Este (1505–1534), who brought together painters such as Raphael from Rome and Giovanni Bellini and Titian from Venice. The collection of pictures that the duke assembled, however, focused primarily on the work of two local artists, the brothers Dosso and Battista Dossi.

The work of the Dossi combined elements of the Venetian style, as exemplified by Giorgione and Titian, with that of Tuscan or Roman artists such as Raphael. The brilliant color and poetic mystery of the Venetians pervade the brothers' works, but they also demonstrate a fascination with classical motifs, elaborate compositions, and figural poses that seem to derive from Rome. The Museum's canvas, one of the largest surviving works by Dosso, exemplifies all of these influences.

Many of Dosso's best pictures still defy precise explanation because of their complex themes and eccentric or obscure allegorical programs. The Museum's painting is generally assumed to be mythological because the Greek god Pan appears on the right. It has been suggested that the wonderful nude lying in the foreground could be the nymph Echo, whom Pan loved; the old woman may be Terra, Echo's protector. The music books on the ground would then refer to Echo's musical talents.

Dosso did not intend the woman in the flowing red cape on the left to be seen. After completing this figure, he painted over her with a landscape; this was scraped off at some more recent date. The artist's "final" composition contained only three principal figures, and without the red cape, it was more subdued in color. At some time in the past, the painting was also cut down by about six inches on the left side, so that the figures originally dominated the composition to a lesser extent than they do now.

In spite of the changes that prevent us from seeing the painting exactly as the artist intended, it can be described as one of the most sensual and ambitious of Dosso's works. The beautifully detailed flower petals in the foreground, the almost flamboyant lemon tree, and the fantastic landscape on the left display an exuberance and individuality that are hardly matched by any of the artists's illustrious contemporaries.

BF

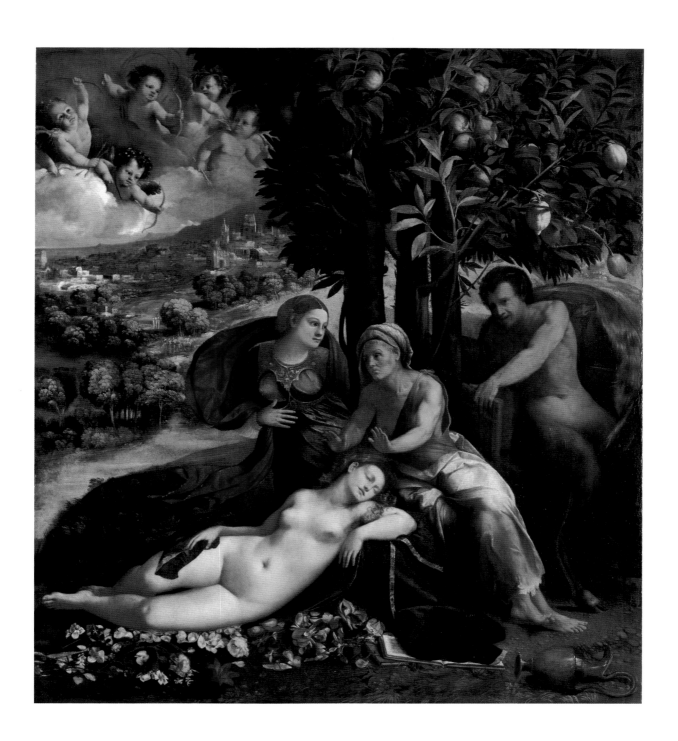

DOSSO DOSSI (GIOVANNI DE' LUTERI)

ITALIAN, active 1512–1542
Allegory of Fortune, 1530s
OIL ON CANVAS
178 × 216.5 cm (70 ½ × 85 ½ in.)
89.PA.32

This recently discovered painting was executed by Dosso at least a decade after the *Mythological Scene* illustrated on the preceding page. While the luminous, poetic coloring and atmosphere of the earlier work reflect Dosso's study of contemporary Venetian paintings, the *Allegory of Fortune* illustrates how his work developed toward a more Roman style dominated by the figure. In fact, the heroically proportioned and posed figures of the *Allegory* are closely based on examples in Michelangelo's Sistine ceiling.

The woman represents Fortune, or Lady Luck, the indifferent force that determines fate. She is nude and holds a cornucopia, flaunting the bounty that she could bring. She wears only one shoe to indicate that she not only brings fortune but also misfortune. While these characteristics conform to traditional depictions of Fortune, Dosso handles her other attributes creatively. Fortune had often been shown with a sail to indicate that, like the wind, she is inconstant, but Dosso employs an artful flourish of billowing drapery. Likewise, Fortune was often depicted balancing on a terrestrial or celestial sphere to indicate the extent of her influence, but with characteristic wit, Dosso has her sit precariously on a bubble, a symbol of transience, to stress that her favors are often fleeting.

The man can be understood as a personification of Chance, in the sense of luck (*sorte*) rather than opportunity (*occasio*). He looks longingly toward Fortune as he is about to deposit paper lots or lottery tickets in a golden urn. This was not a traditional attribute but rather a timely reference, because civic lotteries with cash prizes had recently become popular in Italy.

This is not the only association that paper lottery tickets would have had for the society in which Dosso worked. The bundle of lots would also have been recognized as an emblem of Isabella d'Este, Marchioness of Mantua. One of her learned advisors stated that she chose this image to denote her personal experience of fluctuating fortune. It is possible that Dosso created this painting for Isabella and that its meaning is tied to the vicissitudes of her life at the court of Mantua. Whether or not this is ever established with certainty, the haunting mood of the painting invites the viewer to reflect on how life still seems at the whim of Lady Luck.

DC

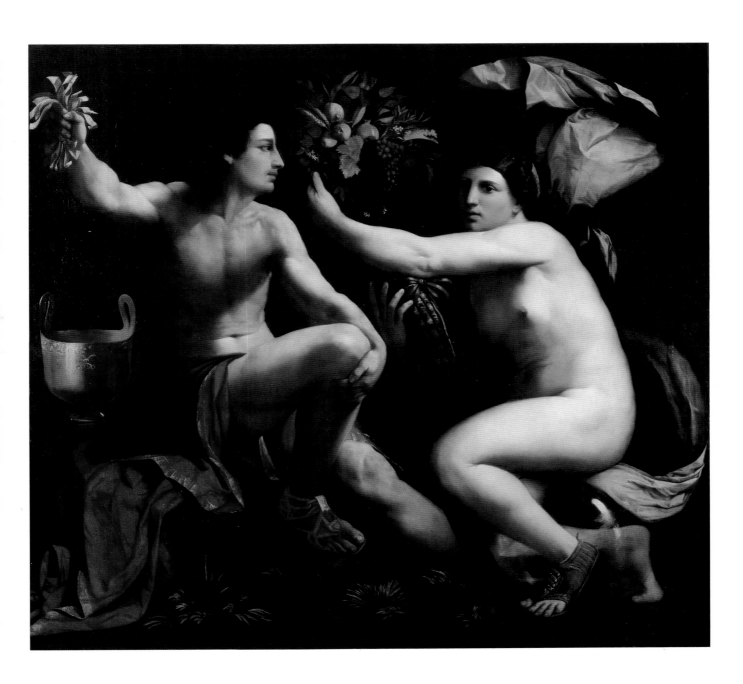

Pontormo (jacopo carucci)

8

Italian, 1494–1557
Portrait of a Halberdier (Francesco Guardi?), 1528–1530
OIL ON PANEL TRANSFERRED TO CANVAS
92 × 72 cm (36 ¼ × 28 ¾ in.)
89.PB.49

Jacopo Pontormo was one of the founders of the so-called Mannerist (stylish-style) School in Italy, and after Michelangelo he is recognized as the most important Florentine painter in the sixteenth century. He and his pupil Bronzino excelled as face makers, and the halberdier is Pontormo's greatest achievement.

Much has been written about the identification of the sitter. In 1568 the most famous contemporary recorder of artists' lives, the painter Giorgio Vasari, noted that Pontormo painted a most beautiful work, a portrait of Francesco Guardi, depicted as a soldier during the 1528 siege of Florence. The name of a rival claimant, Cosimo de' Medici, is attached to a 1612 description of the portrait made for the Riccardi family. Motives such as political patronage might explain the later romantic identification of the sitter with a Medici duke whose familiar bulging eyes and other features actually bear no resemblance to the portrait. We know nothing about Francesco Guardi's appearance, yet he was born in 1514, so he could be the teenage sitter. Furthermore, the portrait is Pontormo's masterpiece, so its quality readily suggests an "opera bellissima" whose dimensions could support a painted cover, showing Pygmalion with his statue made flesh that Vasari tells us Pontormo's talented pupil Bronzino made for Francesco's image. The debate hinges on the attraction of artistic brilliance as against famous lineage.

Pontormo shows his halberdier before a bastion suggesting the defense of Florence. This youth is posed like some new Saint George or David guarding his city. Some physical confidence is conveyed by his casual, swaggering pose. His loose grip on the halberd (spear) and slung sword suggests a control that is denied by his expression.

The message is reinforced by his garb. His red cap, the kind that fashionable courtiers wore, is casually cast across his head. It is decorated by a hat badge showing Hercules overcoming Antaeus. Hercules was the legendary founder and symbolic protector of Florence among many cities and families, and he never shrank from the endless challenges that confronted him. Our unbloodied fighter stares into the unknown, and his anxious expression suggests he has just become aware of the myth of the immortality of youth.

The paint work is captivating, be it the magnolia-like petals of the white ruffs or the creamy concertina-like folds down the billowing sleeves. A battery of abstract design concepts is used to create a vibrant personality, a Pygmalion achievement as impressive as giving life to stone.

DJ

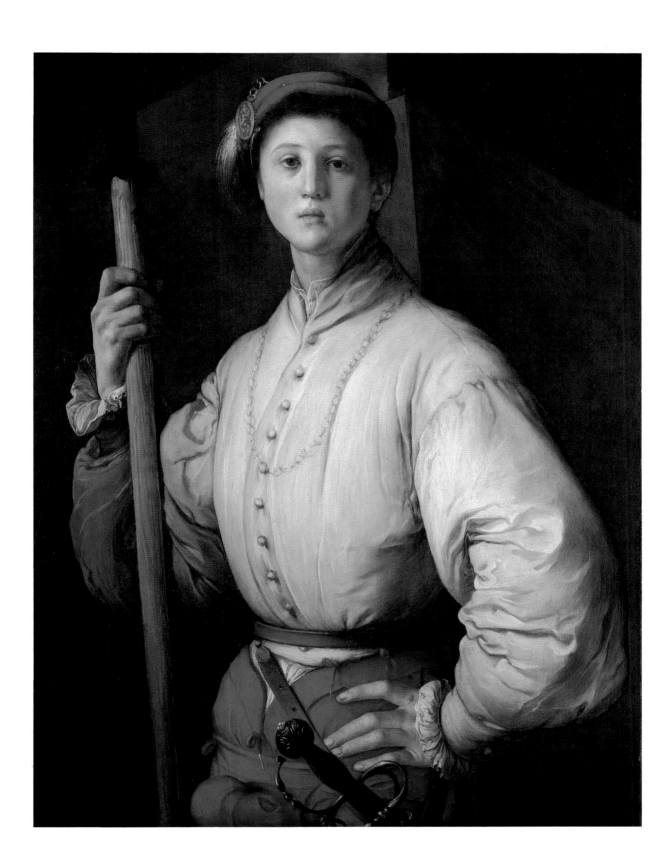

SEBASTIANO DEL PIOMBO (SEBASTIANO LUCIANI)

ITALIAN, circa 1485–1547
Portrait of Pope Clement VII, circa 1531
OIL ON SLATE
105.5 × 87.5 cm (41 ½ × 34 ½ in.)
92.PC.25

This portrait depicts Giulio de' Medici (1478–1534), who reigned as Pope Clement VII from 1523. An outstanding humanist, Clement is principally remembered as one of the greatest patrons of the Renaissance. His art commissions include Raphael's *Transfiguration* (Rome, Pinacoteca Vaticana), Michelangelo's Medici Chapel and Laurentian Library (Florence, San Lorenzo), as well as the *Last Judgment* for the Sistine Chapel (Rome, Vatican). Clement was also Sebastiano's greatest benefactor, from the commission for the *Raising of Lazarus* (London, National Gallery) in 1517 to the bestowal of the high office of Keeper of the Papal Seals in 1531.

Sebastiano's portrait style has a distinctive monumental grandeur, particularly suited to state portraits like this one. The painter's characterization of his subject reflects the Renaissance cult of individuality in its bold projection of a powerful, unmistakably individual presence. The pontiff seems to possess innate nobility and self-confidence, befitting both his position and his personality.

The pope is depicted in three-quarter length, seated in an armchair which is canted diagonally to the picture plane. The first independent papal portrait to adopt this format was Raphael's *Portrait of Julius II* (London, National Gallery) of 1511–1512. Sebastiano's several portraits of Clement VII are the next images to use the compositional arrangement, establishing it as the standard for state portraits of the pontiff. Thereafter, the formula has been followed almost invariably by the pope's painters and photographers to the present day.

This portrait is probably the one ordered by the pope from Sebastiano by July 22, 1531, when the painter wrote to Michelangelo about it. By that date, one portrait of the pontiff had been completed on canvas. The pope wanted another portrait of the same type painted on stone and this painting is the only extant work to fit that description.

Aspiring to eternalize his works, Sebastiano began to experiment with painting on stone about 1530. Slate had not often been used as a support for painting, but Sebastiano came to favor it for especially important commissions. The pope seems to have shared his concern with longevity as he specified the stone support for his portrait. They both knew that wood and canvas would rot, and that slate is extremely durable, as long as it is not dropped.
DC

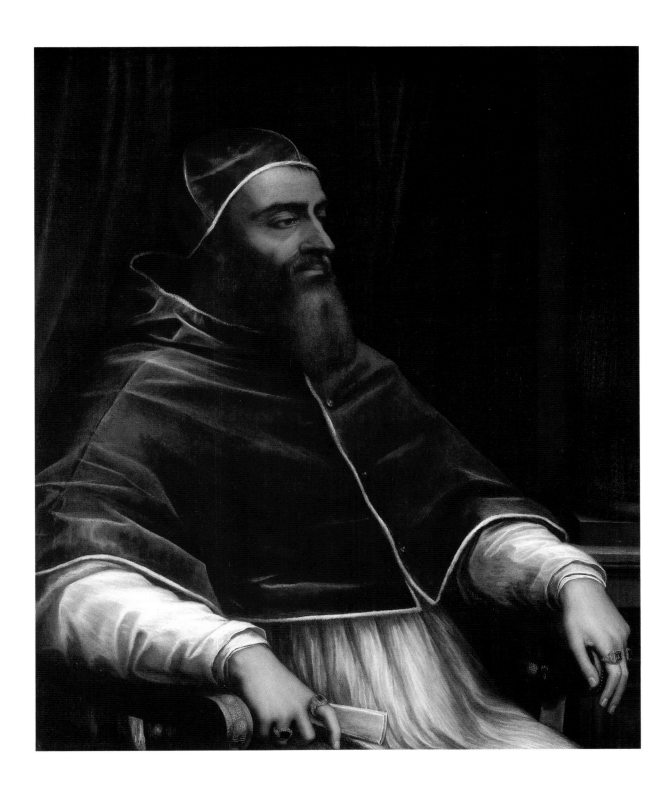

Francesco Salviati (francesco de' rossi)

Italian, 1510–1563
Portrait of a Bearded Man, circa 1550–1555
OIL ON PANEL
108.9 × 86.3 cm (42 ⅞ × 34 in.)
86.PB.476

Portraiture has always been a part of the European painting tradition, but its potential for enhancing the political, social, and historical image of the subject was not fully realized or exploited in painting until the sixteenth century, during the High Renaissance. It was at this time that prospective sitters from a number of social levels fully came to understand how effectively portraiture could be used to control the way in which they were perceived by their peers or subjects.

Among those most successful at conveying the authority of their sitters were artists working in Florence and Rome, such as Bronzino and Francesco Salviati. Both men painted large numbers of portraits, and both excelled to the extent that they are best remembered today for these pictures rather than their figure compositions. Each artist succeeded in finding extensive patronage among the nobility, the wealthier merchant classes, and members of the court. Their depictions of stern, almost statuelike sitters are an important record of central Italian society of the time.

Bronzino was active most of his life in Florence, and his patrons, among them the powerful Medici family, were largely from that city. Salviati, who was greatly influenced by Bronzino and was in many ways his follower, was active in both Florence and Rome. His patronage was less consistent, however, and the names of his sitters are not always known. It is therefore particularly difficult to date Salviati's paintings accurately. This is true of the present painting, probably Salviati's portrait masterpiece. We know only that it comes from Florence and that the sitter was therefore probably a Florentine.

The artist has given his subject a very imposing air. Placed against a cascade of green drapery, his gaze is penetrating and his demeanor, severe. He holds a letter, something akin to a note of introduction, but his stance does not suggest any inclination to be introduced; instead, it emphasizes his dignity and prestige.

Portraits of this sort, normally only half-length, are the painted counterparts of ancient Roman statues, and they have an almost marblelike quality. They are not painterly and lack a freedom of brushstroke and a love of spontaneity; instead, they are meant to suggest permanence and invulnerability.

BF

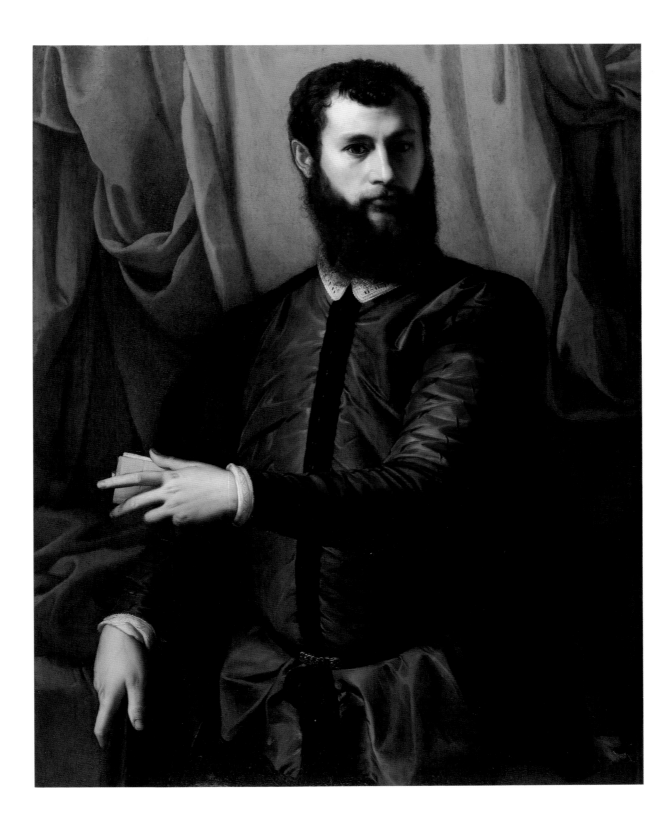

Titian (tiziano vecellio)

Italian, circa 1480–1576
Venus and Adonis, circa 1555–1560
160 × 196.5 cm (63 × 77 ⅜ in.)
oil on canvas
92.PA.42

The Venetian painter Titian's dominance of the international art world of his time arose from his ability as a state portrait maker and as an illustrator of classical mythology. *Venus and Adonis* was one of his most famous mythological compositions. The story from Ovid's *Metamorphoses* tells how the goddess of love failed to persuade the hunter to stay with her and he instead rushed off to his death. The slumbering cupid with ineffective love arrows still in the quiver, and the mateless partridge beside the upturned wine jug, all indicate that Venus's last impassioned glance will fail to restrain the too-bold hunter. Designed originally for one of his closest and most supportive patrons, Philip ii, king of Spain, the present painting is one of many more mature free variants painted for some as yet unidentified admirer. Titian wrote to Philip that his Adonis was to show a back view as foil to his earlier frontal nude composition. Faced with the sensuously compressed buttocks, it is easy to simply read such paintings as "girly pinups," as indeed did several of his contemporaries. In fact Titian's challenge was to render the ancient mythology in a believable and enticing way. As had Raphael and Correggio before him, Titian drew inspiration from an ancient bas-relief. Such a quotation of a Roman invention is at the heart of our concept of the Renaissance as the rebirth of ancient art, and for Titian it was a way of authenticating his composition. But he has translated the image in a series of centrifugal forces, showing Adonis unraveling himself from Venus's embrace while one of his hunting dogs turns back with glistening eye to contemplate the pleasures relinquished for those of the chase. The canvas is replete with Titian's house-style of painting, visible in the drapery fold highlights which enliven the cloth in sharp zigzags, almost as if charged with static electricity, the almost imperceptible modeling of flesh, the flashy curls of hair and the staging of Adonis's cape, which shimmers against the evocative mountains. Venetian artists were famous for their preoccupation with the painterly rendering of the effects of light on surfaces, designing in color and not just line, and Titian was a genius at using these effects to create evocative moods. Titian's task was to make a Lord of the Rings kind of fantasy world both believable and desirable, and he has succeeded in bringing its superhuman protagonists alive and convincing us of their tragic love story.

Although the central figures may have been generated from a tracing of the Prado version kept in the artist's studio, their surroundings have been reinvented.

DJ

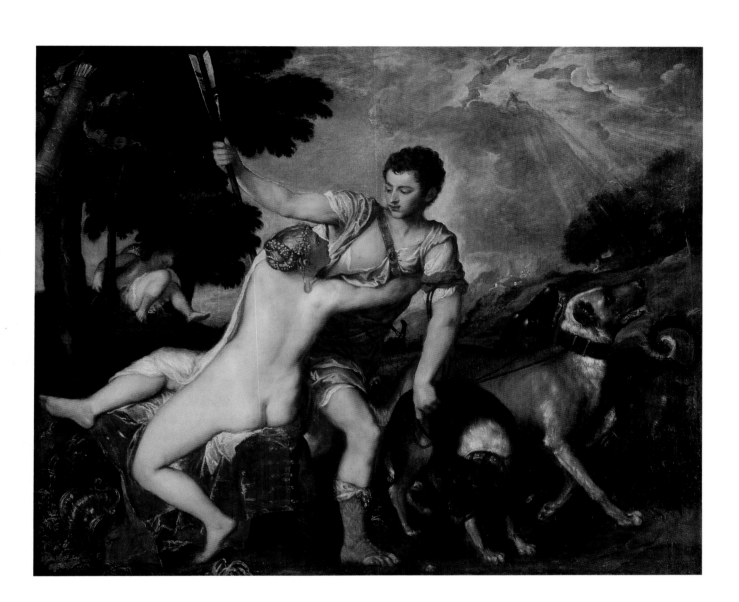

Veronese (paolo caliari)

Italian, 1528–1588
Portrait of a Man, circa 1570
OIL ON CANVAS
193 × 134.5 cm (76 × 53 in.)
71.PA.17

The subject of this imposing portrait leans on a large socle, or base, supporting fluted columns; between these columns is a niche containing a marble sculpture of a draped figure, only the lower portion of which can be seen. Carved reliefs adorn the sides of the socle, the exact subjects of which are not discernible. The man stands on a pavement of inlaid stone, and in the distance to the left, the distinctive features of the Venetian church of San Marco can be seen. The church is incongruously surrounded by trees as if it were in a forest instead of its actual urban setting. All of these details seem intended to provide clues to the subject's profession or identity. Perhaps he had some connection with San Marco, although this would not explain the church being represented in this unusual setting. He may have been an architect or even a sculptor, but nothing about his clothing or his appearance confirms this. The sword at his side, in fact, suggests that he may have been a nobleman.

Traditionally, the subject was described as the artist himself, but this cannot be confirmed. There are some indications that Veronese may have been bearded, and he seems to have had a high forehead, but his exact appearance is unknown. It seems unlikely, however, that he would have painted himself standing in formal clothing against some columns with a sword at his waist, and he had no special connection with the church of San Marco.

Perhaps because he had so many commissions to paint large decorative cycles in Venice, Veronese generally avoided less lucrative categories, such as portraits, for which his contemporaries Tintoretto and Titian became better known. In spite of the fact that he did not depend upon his reputation as a portraitist, he was a very skillful one, and the size and beauty of the present example—one of the most striking of the few he undertook—indicate that it must have been a particularly important commission for him. It is executed with a painterly verve and freedom of execution that characterize all of the artist's work.
BF

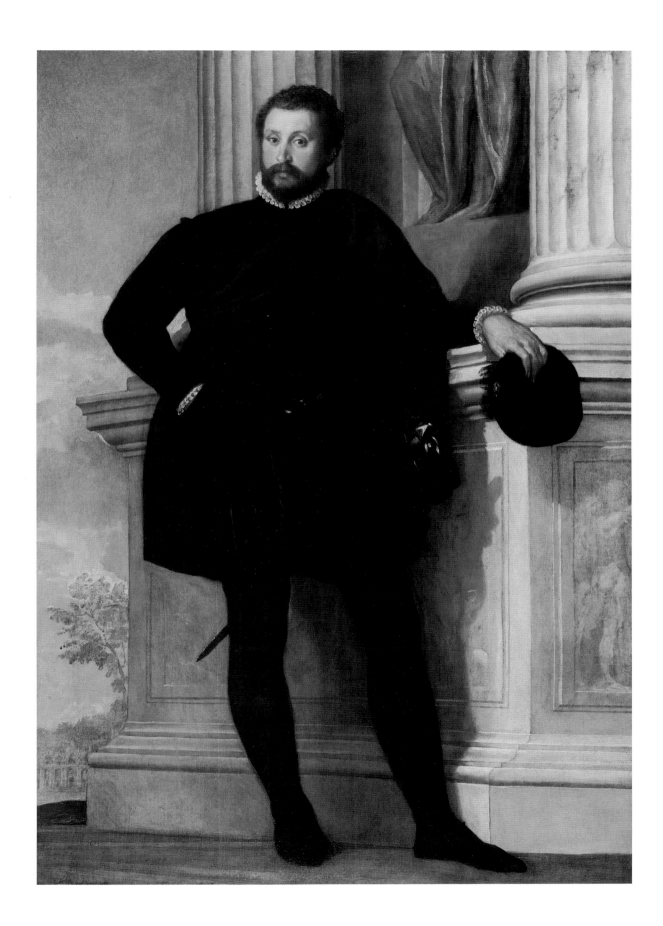

DOMENICHINO (DOMENICO ZAMPIERI)

ITALIAN, 1581–1641

Christ Carrying the Cross, circa 1610

OIL ON COPPER

53.7 × 68.3 cm (21 ⅛ × 26 ⅝ in.)

83.PC.373

13

The impetus of papal commissions and the extensive construction that took place during the sixteenth and seventeenth centuries made Rome the center of artistic activity on the Italian peninsula for the first time since antiquity. Relatively few artists involved in this resurgence were natives of the city or were trained there until later in the seventeenth century, and a tradition had developed of importing leading artists from other centers with longer- and better-established schools. In the early years of the seventeenth century, the largest number of these artists came from Bologna and were allied with the movement founded by the Carracci family, a school that flourished in central Italy for over a century.

Domenichino, a prominent member of this group, arrived in Rome in 1602. He worked closely with Annibale Carracci and over the next four decades remained one of his most loyal adherents.

Domenichino's career was marked by a series of important fresco projects, but he also painted a number of religious pictures for individual patrons. During his first decade in Rome, he painted a few of these on copper, a support that was popular for small compositions requiring a high degree of finish. The Museum's copper is one of the masterpieces of this early period. It was probably executed about 1610 and is particularly indicative of the care that the artist devoted to his work.

Domenichino emphasized the careful planning of composition and individual figures, and his execution was exceptionally painstaking. Along with the Carracci, he stood in opposition to the "realist" movement led by Caravaggio and his followers, maintaining instead that nature must be ordered and improved upon. This stance was a rational one, and typically, *Christ Carrying the Cross* does not emphasize the Savior's suffering, in spite of the brutality of the subject. Domenichino imparted a sense of strength to his figures but eschewed dramatic exaggeration of any kind. The compression of the figures at the sides of this composition may be deliberate, or it may be in part the result of the copper panel having been trimmed at some time in the past.

BF

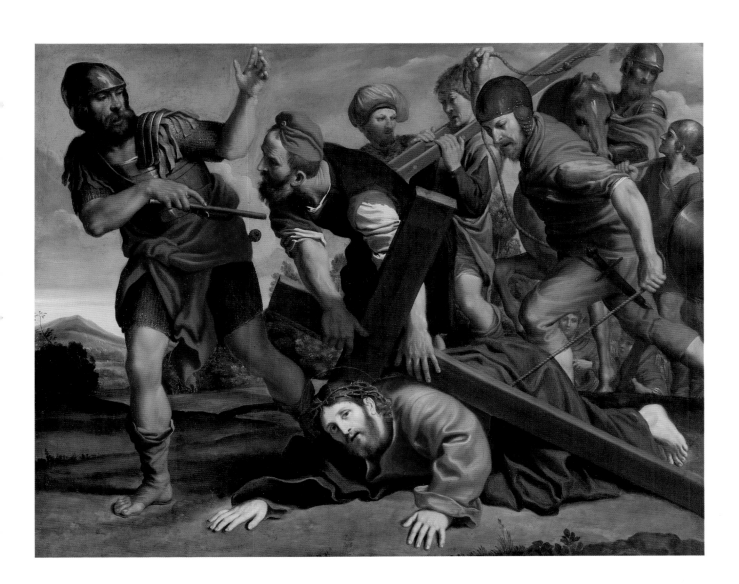

Canaletto (giovanni antonio canal)

Italian, 1697–1768
View of the Grand Canal: Santa Maria della Salute and the Dogana from Campo Santa Maria Zobenigo, mid-1730s
OIL ON CANVAS
135.5 × 232.5 cm (53 ¼ × 91 ¼ in.)
91.PA.73

14

Canaletto was the most sought-after of the eighteenth-century *vedute* (idealized landscape) painters. A contemporary defined his contribution as the ability to make the sun shine in his canvases. Yet, the underpinnings of this naturalism was often artifice; scholarship on the artist has long recognized the subtle topographical adjustments necessary to achieve such seemingly casual views.

Initially trained as a painter of theatrical scenery, Canaletto created more than architectural records in his city scenes. Richly observed in anecdote as well as physical detail, Canaletto's urban views are enlivened by their human element, capturing simultaneously the aging grandeur of the city and the momentary quality of everyday life within it.

In this sweeping view of the Grand Canal, Canaletto presents a cross-section of Venetian society going about their business on a sunny morning. In the left foreground, the facade of the Palazzo Pisani-Gritti presents an elegant backdrop to the mundane activities of the *campo* bank. The exuberant Baroque design of Baldassare Longhena's Church of Santa Maria della Salute dominates the opposite bank of the canal. To the right, the sun-bathed facade of the Abbey of San Gregorio rises above a shadowy row of houses. On the far side of the Salute stand the Seminario Patriarcale and the Dogana. The mouth of the canal opens onto a distant vista with the Riva degli Schiavoni visible beyond the bustling commerce of the Bacino di San Marco. Over the dogana wall can be seen the pale campanile and dome of San Giorgio Maggiore.

This is the primary version of a composition repeated in at least fourteen versions by Canaletto's studio, which included his nephew, Bernardo Bellotto (1721–1780), and his many imitators, in England as well as in Italy. The precise nature of Canaletto and Bellotto's collaboration at this point is still not fully understood. A pen-and-ink drawing by Bellotto in the Hessisches Landesmuseum, Darmstadt, follows the Getty composition closely, even down to the figural groupings. The Cleveland Museum of Art's *View of the Piazza San Marco Looking Southwest*, long considered the pendant of the Getty *Grand Canal*, has recently been re-attributed to Bellotto.

PS

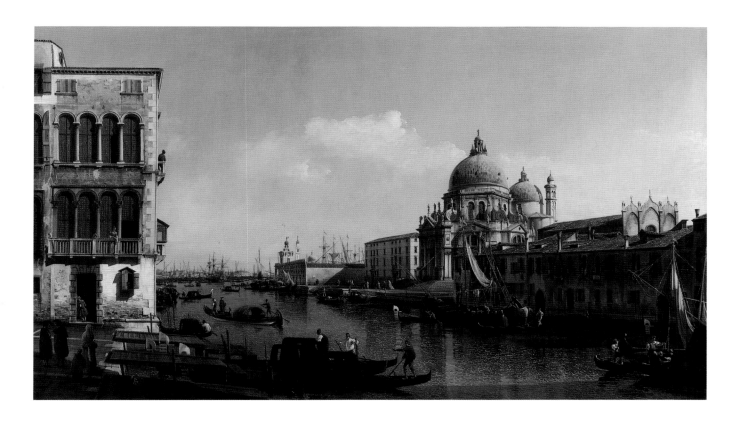

GIAMBATTISTA TIEPOLO

15

ITALIAN, 1696–1770
The Miracle of the Holy House of Loreto, circa 1744
OIL ON CANVAS
123 × 77 cm (48 ⅜ × 30 ⅜ in.)
94.PA.20

This sketch depicts the legend, first recorded in the late fifteenth century, of the miraculous flight of the Virgin Mary's Holy House, or Santa Casa. According to the legend which had particular currency in eighteenth-century Venice, the house where Mary had been born and where the Annunciation had taken place was transported by angels in 1291 from Nazareth in the Holy Land to Loreto, a small town on Italy's Adriatic coast, when it came under threat of desecration by invading Saracen armies.

Tiepolo condenses the subject to a tripartite compositional scheme seen *di sotto in sù*, where figures diminish in scale toward the upper part of the composition. Across the top, depicted in near-grisaille, God the Father and the dove of the Holy Spirit preside amid a chorus of music-making angels. Filling the central area of the canvas, a rustic single-gabled house is convincingly borne aloft by a mass of angels, a feat heralded by three trumpeting angels to the right. The Christ child gazes down from the arms of the standing Virgin Mary as the two are conveyed on the rooftop, framed by billowing drapery. Saint Joseph, arms raised overhead, rides a cloud alongside. Closest to the viewer's space, heretical figures fall away from the miraculous scene, filling, and overflowing the lower register with a dark, flailing mass. A crowd of armed, turbanned figures watch from the periphery.

The sketch represents the artist's final preparations before beginning the fresco for the central vault of the church of the Scalzi, or Discalced Carmelites in Venice, known as Santa Maria di Nazareth. Designed by Baldassare Longhena in the mid-seventeenth century, it was, by Tiepolo's time, one of the most lavishly decorated churches in Venice. Collaborating with Girolamo Mengozzi-Colonna who painted the illusionistic architectural surrounds, Tiepolo completed the commission between 1743 and 1745.

With the Scalzi ceiling unfortunately destroyed by bombing in World War I, the Getty sketch provides the best indication of the breadth and luminosity the artist envisioned for what would be his most magnificent ceiling decoration with a religious theme. The witty foreshortening of putti, the stately demeanor of the Virgin, and the artful disarray of angel limbs all show the artist at his best.

PS

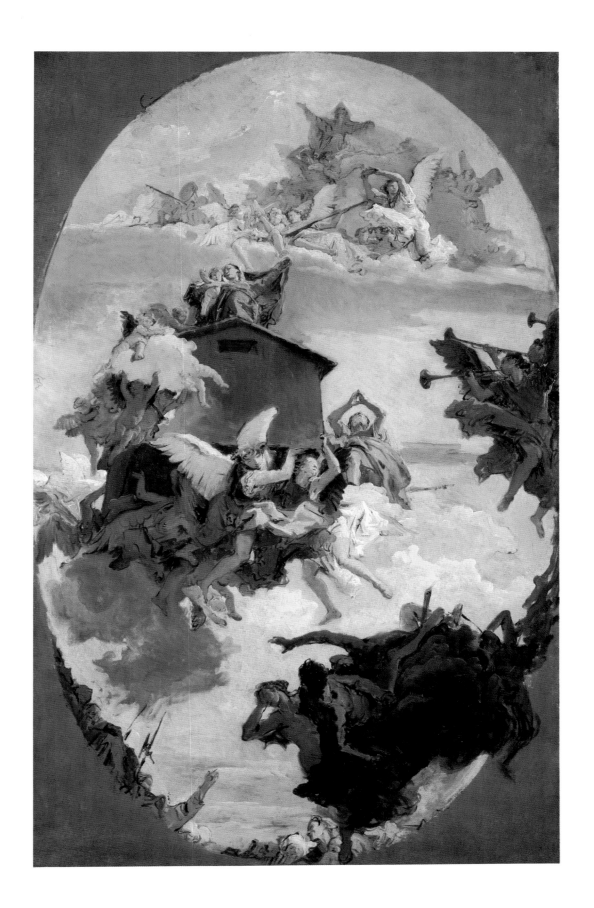

DIERIC BOUTS

FLEMISH, active circa 1445–died 1475
The Annunciation, circa 1450–1455
DISTEMPER ON CANVAS
90 × 74.5 cm (35 ⁷⁄₁₆ × 29 ⅜ in.)
85.PA.24

The Annunciation belongs to a set of five paintings that originally constituted a polyptych—an altarpiece that evidently consisted of an upright central section flanked on each side by two pictures, one above the other. The other scenes in this series have been identified as the *Adoration of the Magi* (private collection), *Entombment* (National Gallery, London), *Resurrection* (Norton Simon Museum, Pasadena), and probably the *Crucifixion* in the center (perhaps the painting now in the Musées Royaux d'Art et d'Histoire, Brussels). Because the Getty painting depicts the earliest scene in the life of Christ, it was probably placed at the top left-hand corner of the altarpiece.

Dieric Bouts was active in Louvain (in present-day Belgium) during all of his mature life. He was the most distinguished of the artists who followed in the footsteps of Jan van Eyck (active 1422–died 1441) and Rogier van der Weyden (1399/1400–1464), although much less is known about his life and relatively few of his paintings survive. His style was generally more austere than that of his contemporaries, and his work consistently projects a sense of restraint. It is also typified by great precision.

In *The Annunciation*, the artist has provided a typically convincing sense of space and has gone beyond his predecessors in allowing us to feel the character of Mary's private chamber. It is a relatively colorless sanctuary, much like the cells inhabited by the monks and nuns who normally commissioned and lived with such altarpieces. The exception to this austerity is the brilliant red canopy over the bench behind Mary. The symbolic lily, normally present in depictions of this scene, has been omitted, and the conventionally colorful floor tiles are much subdued. The Virgin wears a grayish mantle rather than the usual deep blue, and Gabriel is dressed in white, not the highly ornamented clothing usually worn by archangels. Such details were often stipulated in advance by the ecclesiastics who commissioned a work, and in these departures from tradition, a message is probably being conveyed that had particular significance for the institution in which the altarpiece was to be seen.

The Annunciation, like the other sections of the altarpiece, was painted on linen rather than wood. This was sometimes done to make a painting more portable, but it is highly unusual for a polyptych of this size.
BF

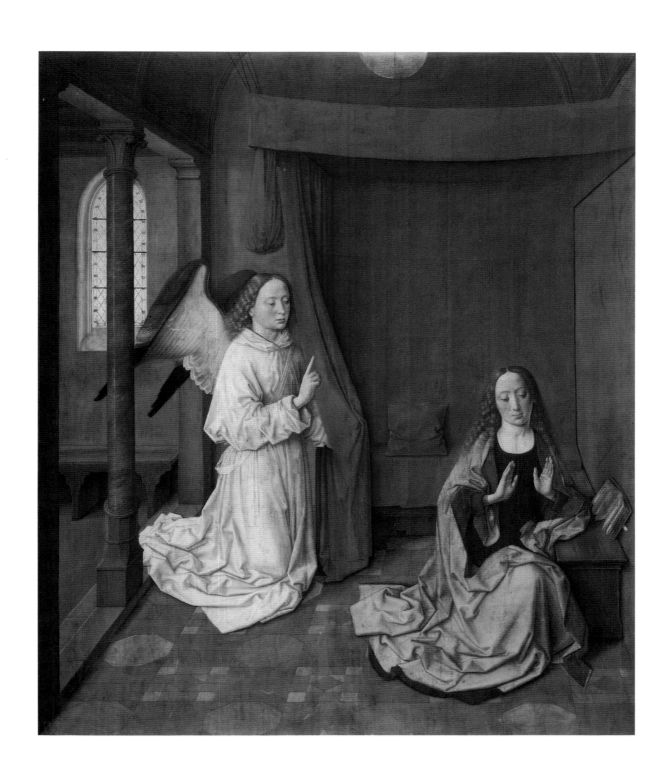

Joachim Wtewael

Dutch, 1566–1638
Mars and Venus Surprised by Vulcan, 1606–1610
OIL ON COPPER
20.3 × 15.5 cm (8 × 6 ⅛ in.)
At bottom right, signed *JOACHIM WTEN/WAEL FECIT*
83.PC.274

This enchanting painting on copper, one of the Museum's smallest and most precious, depicts a story from Ovid's *Metamorphoses* in which Vulcan, in the company of other gods, surprises his wife, Venus, who is in bed with Mars. Vulcan on the right removes the net of bronze, which he had forged to trap the adulterous pair, while Cupid and Apollo hover above, drawing back the canopy. Mercury, standing near Vulcan, looks up gleefully toward Diana while Saturn, sitting on a cloud near her, smiles wickedly as he gazes down on the cuckolded husband. Jupiter, in the sky at the top, appears to have just arrived. Through an opening in the bed hangings Vulcan can be seen a second time in the act of forging his net.

Mythological themes of this kind were especially popular during the sixteenth century, when interest in the classical world reached a peak. The present rendering of the infamous legend of Mars and Venus exemplifies the Dutch fascination with human misbehavior, particularly scenes of lecherous misconduct. Wtewael here anticipated the earthy humor of the later seventeenth century—normally focused upon peasants—for which his countrymen became famous.

The use of copper as a support for paintings was especially widespread during the late sixteenth and early seventeenth centuries. The very hard and polished surface lent itself to small, highly finished and detailed pictures. Wtewael worked equally well in both large and small scale and on canvas as well as copper. Copper was well suited for the present picture, since it allowed for subtler gradations of tone and greater intensity of color than canvas. Fortunately, the painting is in perfect condition and virtually as brilliant as the day it was painted. Due to the erotic subject matter, it may have been kept hidden, and hence protected, over the years.

In his famous treatise on art, *Het Schilder-boeck*, published in 1604, the Dutch writer Karel van Mander reports that Wtewael had painted two tiny coppers of this subject, one of which had been done very recently. The two pictures are thought to be the Museum's *Mars and Venus* and another similar work now in the Mauritshuis in The Hague, which is dated 1601. The Museum's painting was probably the one commissioned for Joan van Weely, a jeweler from Amsterdam.

BF

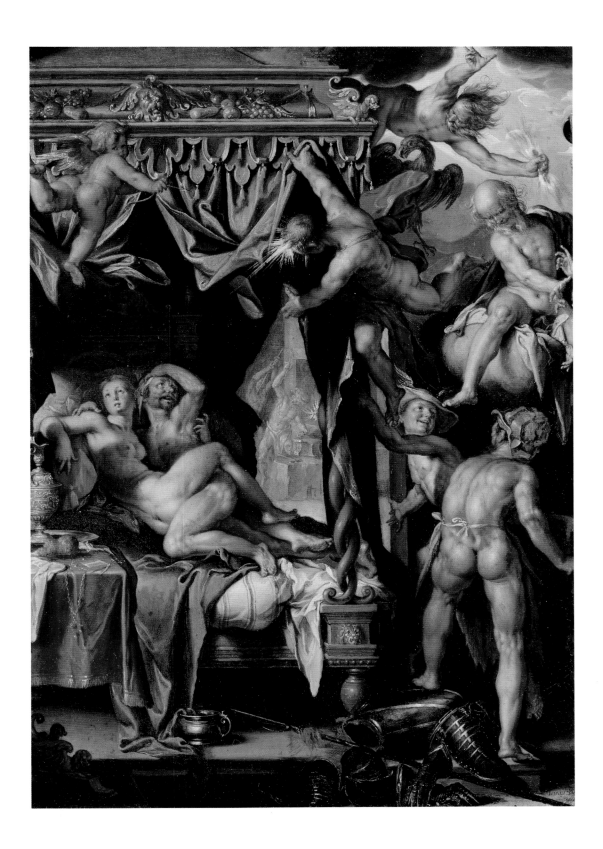

JAN BRUEGHEL THE ELDER

18

FLEMISH, 1568–1625
The Entry of the Animals into Noah's Ark, 1613
OIL ON PANEL
54.6 × 83.8 cm (21 ½ × 33 in.)
At lower right, signed *BRUEGHEL FEC. 1613*
92.PB.82

At the dawn of the modern era in Europe, there was keen interest in the precise rendering of the natural world, as evidenced by the landscapes and still lifes of Jan Brueghel. The artist favored small-scale pictures, brought to a high degree of finish reminiscent of the work of miniaturists. The tonality of his landscapes is quite original, showing brilliantly colored woodland settings that evoke the mood of luxuriant nature. Likewise, the artist had a particular gift for depicting animals.

The story of Noah's ark (Genesis 6–8) provided a subject well suited to Brueghel's abilities. Overcome by the wickedness of the human race, God resolved to cleanse the earth with a great flood. The only exemption was given to the family of Noah, the sole just man. So that a new beginning could be made, God instructed Noah to build an ark and to take on board a male and a female of every species of bird and beast.

Beside a trickling stream that foreshadows the coming deluge, a group of curious people watch in wonder as Noah herds the creatures toward the ark, seen in the middle distance at left. This panel served as the prototype for a whole class of Brueghel's paintings, the so-called Paradise Landscapes, in which the artist celebrates the beauty and variety of creation.

Brueghel's appointment in 1609 as court painter to Archduke Albert and Infanta Isabella Clara Eugenia enabled him to study exotic animals from life in their menagerie in Brussels. However, the depictions of the lions, the horse, and the leopards were inspired by examples in the works of his great friend and fellow artist, Peter Paul Rubens. The lions are depicted in *Daniel in the Lions' Den* (Washington, D.C., National Gallery of Art); the horse appears in several equestrian portraits from Rubens's Spanish and Italian periods; and the leopards appear in *Leopards, Satyrs, and Nymphs* (Montreal Museum of Fine Arts).
DC

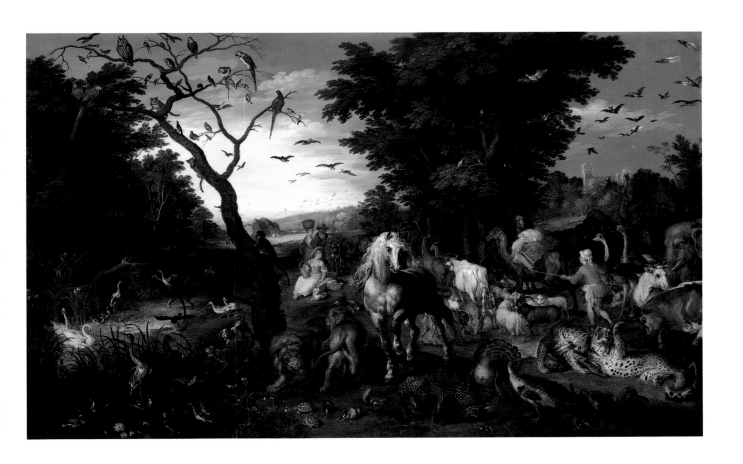

PETER PAUL RUBENS

FLEMISH, 1577–1640
The Entombment, circa 1616
OIL ON CANVAS
131 × 130.2 cm (51 ⅝ × 51 ¼ in.)
93.PA.9

Recognized as the greatest painter of his day, Rubens received commissions from all over Europe and created profound, original statements of virtually every conceivable subject. Among his greatest contributions to Baroque art were religious paintings that express emotion with an intensity that has never been surpassed.

This powerful painting was carefully composed to focus devotion on Jesus Christ's sacrifice and suffering. The beautiful corpse is reverentially supported by those closest to him in life. At left is John the Evangelist. Mary Magdalene weeps in the background as her constant companion, Mary, the mother of James the Younger and Joseph, contemplates Christ's wounded hand at right. The viewer is compelled to join the mourners, whose grief is focused in the Virgin Mary, weeping as she implores heaven.

Rubens was a devout Catholic and his paintings gave tangible form to the main concerns of his religion. To make religious experience more personally resonant, art followed contemporary meditation, which encouraged the faithful to imagine the physical horror of Jesus Christ's crucifixion. Here, the head of Christ, frozen in the agony of death, is turned to confront the spectator directly. Rubens also compels us to regard the gaping wound in Christ's side, placing it at the exact center of the canvas. The composition as a whole, as well as the drawing of the heroic musculature, convey the languid quality of the subject. The atrocity of crucifixion is not underplayed but is handled with consummate art. Thus, the blood emanating from the wound is created by an eloquent passage of brushwork, lovingly applied with the greatest economy of means.

The artist also adds a few symbolic elements to this standard scene of lamentation over the body of Christ. These additions reflect the theological and political concerns of the Counter-Reformation in the early seventeenth century (see the following entry on Honthorst's *Christ Crowned with Thorns*, no. 20). Thus, the slab on which the body is placed suggests an altar, while the sheaf of wheat alludes to the bread of the Eucharist, the equivalent of Christ's body in the Mass. At this time the Roman church was defending the mystery of transubstantiation, the belief in the real presence of the body of Christ in the Eucharist, against Protestant criticism. The allusion to an altar and the eucharistic meaning may indicate that this work was created to serve as an altarpiece in a small chapel, perhaps one dedicated to the adoration of the Eucharist.

DC

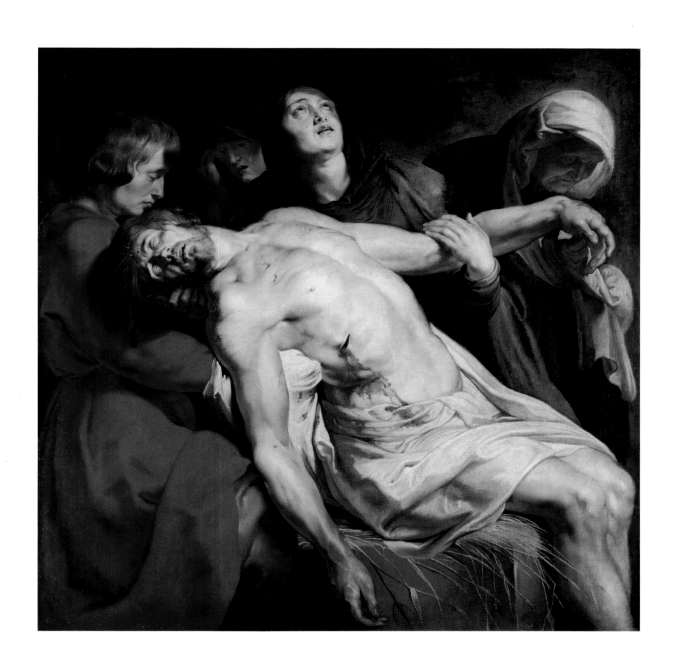

GERRIT VAN HONTHORST

DUTCH, 1590–1656
Christ Crowned with Thorns, circa 1620
OIL ON CANVAS
220.3 × 173.5 cm (87 ½ × 68 ⁵⁄₁₆ in.)
90.PA.26

As was customary for promising Dutch painters, Honthorst traveled to Italy to complete his training, perhaps as early as 1610. In Rome, he fell under the spell of the revolutionary style of Caravaggio, adopting its starkly realistic figures, strong contrasts of light and shadow, and emotionally expressive approach to narrative. Although Caravaggio died in 1610, his art inspired a generation of younger painters, and Honthorst was among the most prominent. The Dutchman remained in Italy until 1620 and perfected the nocturnal scene in which the source of light is depicted, earning the nickname "Gherardo delle Notti"—Gerrit of the Night.

Perhaps created as an altarpiece, this recently discovered painting depicts one of the principal episodes of Christ's Passion. The subject is narrated in three of the Gospels, but Honthorst probably favored the account by Matthew:

> Then the soldiers of the governor took Jesus into the common hall, and gathered
> unto him the whole band of soldiers. And they stripped him, and put on him a scar-
> let robe. And when they had plaited a crown of thorns, they put it upon his head,
> and a reed in his right hand; and they bowed the knee before him, and mocked him,
> saying, Hail, King of the Jews! (Matthew 27:27–29 KJV).

In Honthorst's painting, the subtle play of light from the torch to outlying forms heightens the drama and pathos of the event. The torchlight emphasizes the main point of the scene: Christ humbly accepting the mocking of ignorant mortals. In the shadows, a soldier affixes the crown to Christ's head with a cane to protect his own hands. Barely visible in the distant glow, Honthorst introduces figures, perhaps representing Pilate and an advisor, whose gestures indicate that they are debating the fate of Christ.

This was a popular subject for seventeenth-century devotional paintings, in part because the Counter-Reformation was stressing that meditation on Christ's suffering was essential to the process of individual redemption (see the preceding entry on Rubens's *Entombment*, no. 19). Also, Baroque artists must have been drawn to the expressive potential of the story's contrast of emotions.

DC

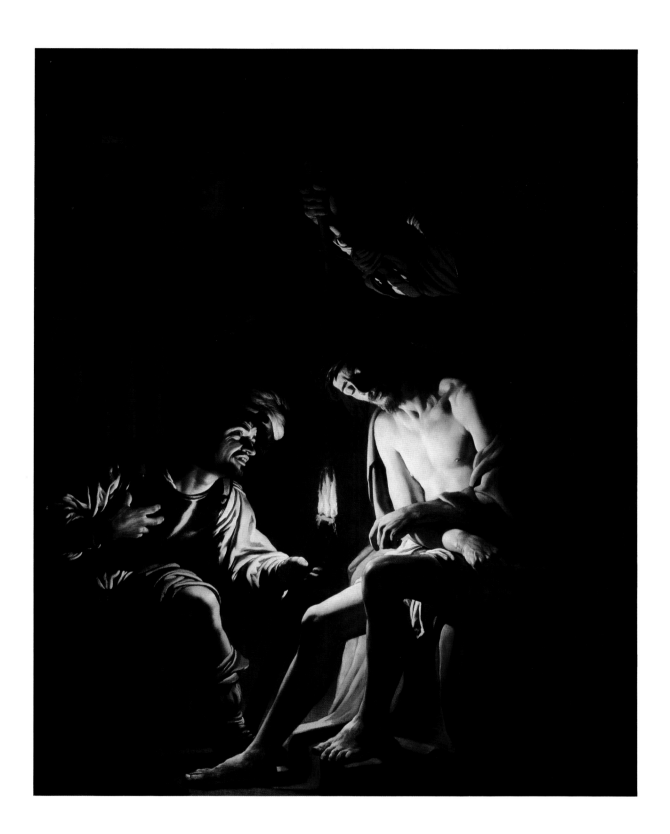

ANTHONY VAN DYCK

21

FLEMISH, 1599–1641
Portrait of Agostino Pallavicini, 1621
OIL ON CANVAS
216 × 141 cm (85 ⅛ × 55 ½ in.)
At top right, near back of chair, signed *Ant^us Van Dyck fecit.*
68.PA.2

Van Dyck's reputation as an artist was already beginning to spread throughout Europe when he traveled to Italy in 1621. He initially went to Genoa, where Flemish contacts had been established for two centuries, largely because the Genoese had strong commercial ties to Antwerp, van Dyck's home. He remained in Italy for five years, traveling about to view large private collections of Italian paintings, and during this time he was extensively employed to paint portraits. It was in Genoa, however, that van Dyck experienced his greatest successes and executed some of his most famous and impressive paintings.

The Museum's portrait depicts a member of the Genoese branch of the Pallavicini family, whose coat of arms may be seen on the drapery to the left, behind the sitter. He is shown in flowing red robes, which almost become the focus of the painting. In his hand he holds a letter; at one time this must have identified him, but it is no longer legible. From other documented portraits, however, it can be established that this is Agostino Pallavicini (1577–1649). The writer Giovanni Pietro Bellori, who in 1672 described van Dyck's stay in Genoa, relates that the artist painted "His Serene Highness the Doge Pallavicini in the costume of Ambassador to the Pope." Pallavicini was not made the doge (the chief magistrate of the Genoese republic) until 1637, but he was sent to Rome to pay homage to the recently elected Pope Gregory xv in 1621, and it is in this capacity that we see him. Thus, the Museum's painting is one of the first executed by van Dyck after his arrival in Italy.

Our present-day image of seventeenth-century Genoese nobility owes more to van Dyck than to any other artist, and the Museum's painting typifies the grandeur and stateliness of his portraits. They are usually life-size and full-length with a background of pillars and swirling, luxurious draperies. At the time, no other artist in Italy could produce the same grand effect, and the result so enthralled the European nobility that van Dyck's style eventually set the standard for portraiture in Italy, England, and Flanders.

BF

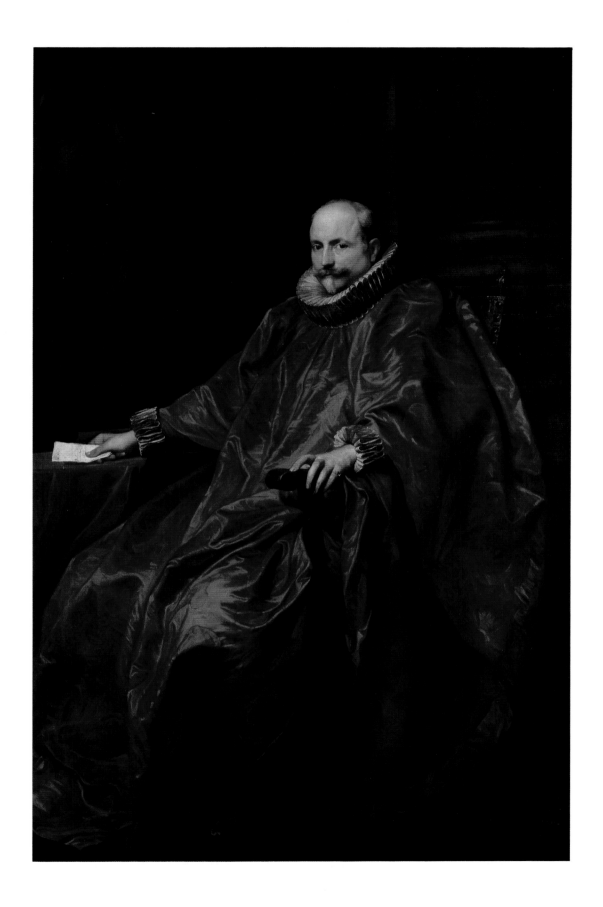

HENDRICK TER BRUGGHEN

22

DUTCH, 1588–1629

Woman with an Ape: Allegory of Taste(?), 1627

OIL ON CANVAS

102.9 × 90.1 cm (40 ½ × 35 ½ in.)

At center right, signed *H ᵀ Brugghen fecit 1627*

84.PA.5

Of all the cities in the predominantly Protestant Netherlands, Utrecht, which had remained the most Catholic in orientation, maintained the closest ties with Italy. Many Dutch artists made the pilgrimage to Italy during the seventeenth century, but those from Utrecht, following a tradition established a century earlier, always showed the greatest stylistic affinity with their Italian colleagues.

Ter Brugghen came from Utrecht and was one of the most important links in this tradition. While in Rome from circa 1604 to 1614, he saw the works of Caravaggio, whose new sense of "realism" held a great fascination for him. Ter Brugghen adopted some of the Italian artist's lighting effects and compositional methods in his own work. His technique, however, which was typified by unusual combinations of colors, often pastels, remained very much his own.

The sitter's pose and the composition of the Museum's painting were almost certainly inspired by two famous depictions of Bacchus, the Greek god of wine, by Caravaggio. Ter Brugghen would have seen these paintings in Rome. In each case the subject is shown half-length and holding grapes. All three figures are rendered with strikingly individual features and a demeanor suggestive of playfulness.

The woman in this painting has traditionally been identified as a bacchante, a follower of Bacchus. She is shown squeezing grapes into a chalice, but she lacks the wreath of vine leaves and other traditional attributes of the deity's disciples. There are some vine leaves on the table in the foreground, as well as a walnut, a pear, and an ape, but they seem almost incidental. The smiling lady's heavy clothing also implies that she occupied a climate too cold to have been hospitable for Bacchic revels. Monkeys or apes are often found in allegories of the sense of taste. Allegories of the senses, however, were usually depicted in sets representing all five, and no other such painting by ter Brugghen is known. In any case the subject is unique, as the vast majority of the artist's works concentrates upon religious subjects or themes drawn from everyday life.

BF

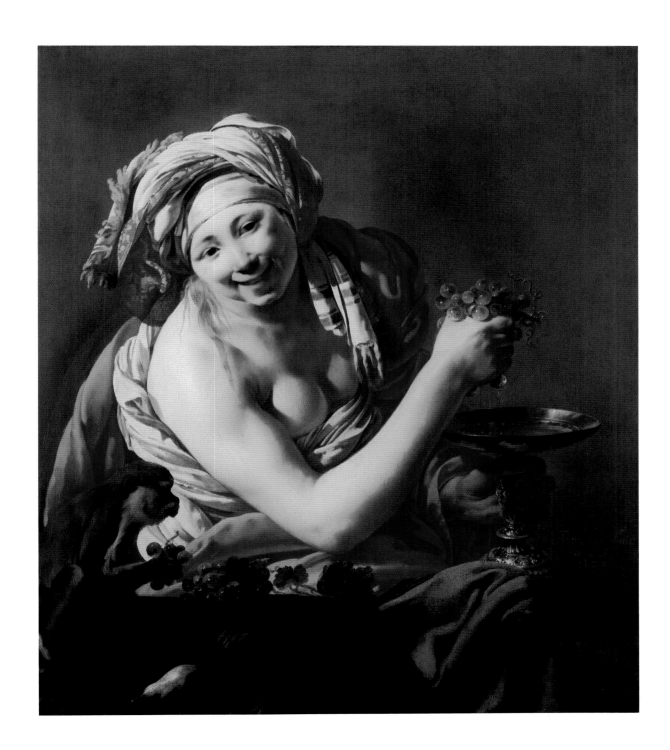

REMBRANDT VAN RIJN

23

DUTCH, 1606–1669
The Abduction of Europa, 1632
OIL ON SINGLE OAK PANEL
62.2 × 77 cm (24 ½ × 30 ⁵⁄₁₆ in.)
On the brown stone below standing women at lower right,
signed *RHL van Ryn.1632.*
95.PB.7

In the *Metamorphoses*, the poet Ovid tells how Jupiter, disguised as a white bull, seduced the Princess Europa away from her companions and carried her across the sea. Rembrandt evokes the substance and lyricism of this classical story by showing Europa as she "trembles with fear and looks back at the receding shore, holding fast a horn . . . her fluttering garments stream[ing] . . . in the wind." He also enriches Ovid's narrative through his vivid characterization of emotion.

Europa, stunned by what has happened, turns toward her two companions. The youngest throws up her arms in horror, dropping the garland of flowers that moments ago was destined for the bull's neck. Her sudden shock contrasts with the contained sadness of her older companion, who clasps her hands in grief as she rises to look at the princess one last time; only she understands Europa's fate, and it is her gaze that the princess meets.

Rembrandt's comedic sense lightens the drama. Jupiter, limited by his disguise, expresses victory in bovine fashion by excitedly extending his tail as he plunges from the shore—so different from the mindlessness of the horses who stand harnessed to the princess's grandiose and immobile carriage. Seemingly too large for the road, and with its sunshade uselessly open in the shadows, the carriage contrasts with the swift white bull who carries Europa into the light toward the new continent that will bear her name.

A luminous landscape also acts as a protagonist in this drama. The meticulously detailed, dark, wall-like stand of trees serves as a foil to the loosely handled, light-shot, pink and blue regions of sea and sky. The unusually low horizon creates an expansive vista where clouds, shore, and sea gently roll toward each other. Along the horizon, shrouded in mist, is Tyre, the city forsaken by Europa.

The carriage's glittering gold highlights or the richly varied textures of the sumptuous costumes show Rembrandt both delighting in his mastery of visual effects and inviting the viewer to share his pleasure in detail. The sea's glowing reflections, the spray tossed up by the well-clad princess's shoe skimming through the water, or her delicate grasp of the soft flesh of the bull's neck captivate the eye and linger in the mind. The painting shows the young artist working at the height of his powers upon his arrival in Amsterdam in 1632.

DA

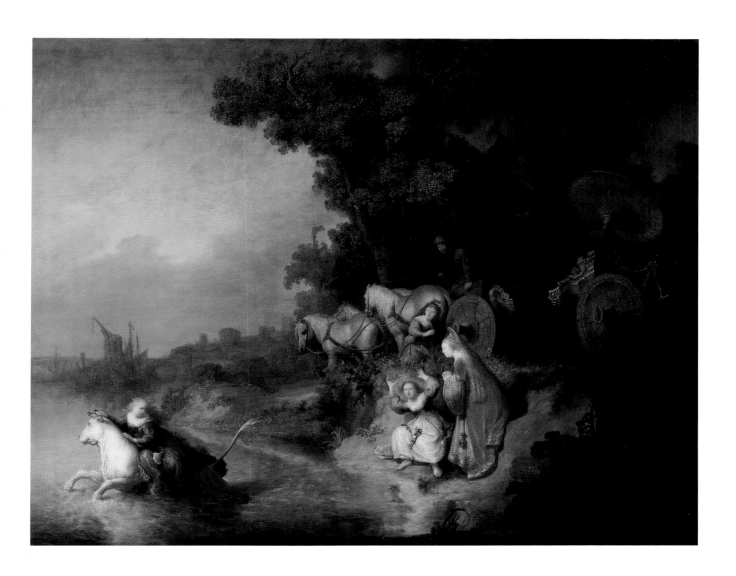

DUTCH, 1606–1669

Daniel and Cyrus Before the Idol Bel, 1633

OIL ON A SINGLE OAK PANEL

23.4 × 30.1 cm (9 ¼ × 11 ⅞ in.)

On the dais at lower right, signed *Rembrant f. 1633*.

95.PB.15

Rembrandt depicts a biblical detective story from the apocryphal portion of the Book of Daniel. It tells of Daniel's unmasking of idolatry at the court of Babylon, where he had become a confidant of King Cyrus the Persian. When Cyrus asked him why he did not honor the deity Bel, Daniel replied that he worshipped the living god, not an idol. Here, the king has just insisted that Bel, too, is a living god, indicating the lavish offerings of fine food and wine he provided for Bel's consumption each night. Daniel gently points out that bronze statues don't eat. While Cyrus is momentarily bewildered, the worried faces of the priests in the background confirm that Daniel is on to something.

Later, the king ordered the temple sealed for the night to determine the truth, but not before Daniel secretly spread ashes on the floor. The next morning the food had indeed vanished, but footprints in the ashes revealed that it was not Bel who feasted, but the seventy priests and their families, having come in through a hidden entrance. Cyrus executed the culprits and gave Bel to Daniel, who destroyed the idol and its temple.

Rembrandt evokes the exotic mystery of a pagan cult by showing only part of the monumental idol emerging from the flickering lamplight. A shaft of light focuses on the human interaction at the heart of the narrative. Rembrandt captures Cyrus's confusion perfectly, causing us to chuckle. We do not even see Daniel's face; his lost profile and body language tell us all we need to know. Perhaps the most poignant aspect of Rembrandt's interpretation is his ironic contrasting of the large, powerful king with the small, humble boy sent by God.

Rembrandt created this painting the year after the *Abduction of Europa*, illustrated on the preceding page. Both works demonstrate his genius as a storyteller and the differences between them are partly explained by the disparate settings and spirits of the texts. However, the comparison also demonstrates how Rembrandt's work evolved toward the more concise, dramatically focused compositions and broad, free handling of paint that are hallmarks of his mature style.

DC

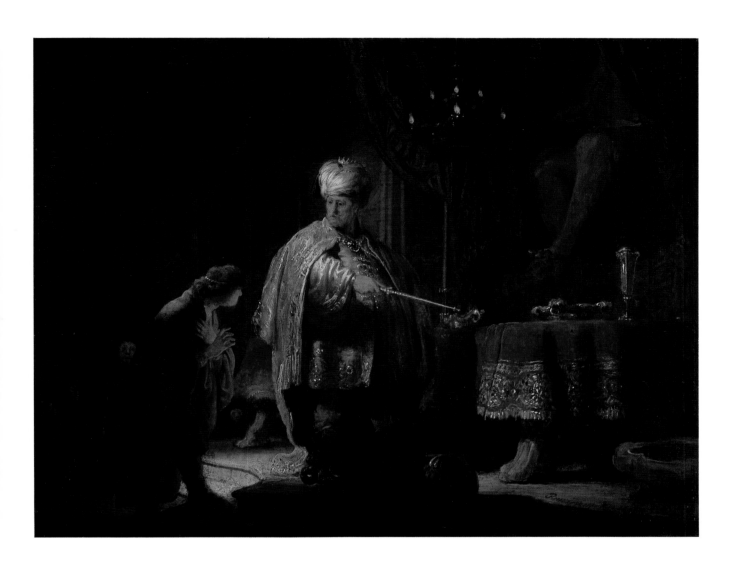

REMBRANDT VAN RIJN

25

DUTCH, 1606–1669
Saint Bartholomew, 1661
OIL ON CANVAS
86.5 × 75.5 cm (34 ⅛ × 29 ¾ in.)
At bottom right, signed *Rembrandt/f.1661*
71.PA.15

The present painting is one of a series of portraits of the apostles that bear the date 1661. The portraits were apparently not meant to be hung together as they are of varying sizes, and it is unlikely that the artist ever depicted all twelve of Christ's disciples. The existence of this series suggests that Rembrandt was perhaps personally preoccupied with the apostles' significance at this time, just eight years prior to his death.

Each of the known portraits gives the impression of having been painted from a model, probably a friend or neighbor, a practice that Rembrandt normally followed. The idea that a common man could be identified with a biblical personage and thereby lend a greater immediacy to Christ's teachings would have been in keeping with the religious atmosphere in Amsterdam at the time. Saint Bartholomew is represented with a mustache and a broad, slightly puzzled face. The stolid, rather pensive, and very ordinary men that Rembrandt often chose as models for these paintings would not be precisely identifiable as individual saints were it not for the objects they hold in their hands—in this case a knife, a traditional attribute referring to the fact that Bartholomew was flayed alive. Their clothing, which in its simplicity is meant to connote biblical times, is very different from the crisp collars and suits worn by the seventeenth-century Dutch upper classes.

Saint Bartholomew is rendered in the broader, freer style of the artist's late maturity. He has used palette knives and the blunt end of his brushes in depicting Saint Bartholomew, and his technique is much more direct than that of any of his contemporaries.

The history of the interpretation of the Museum's painting is of some interest. In the eighteenth century it was thought to depict Rembrandt's cook, in keeping with the taste for everyday subjects, especially servants and humble occupations, that characterized French art of the time. In the nineteenth century, a period enamored of dramatic or tragic themes, the saint was thought to be an assassin, a reading to which the knife and the subject's intense look no doubt contributed.

BF

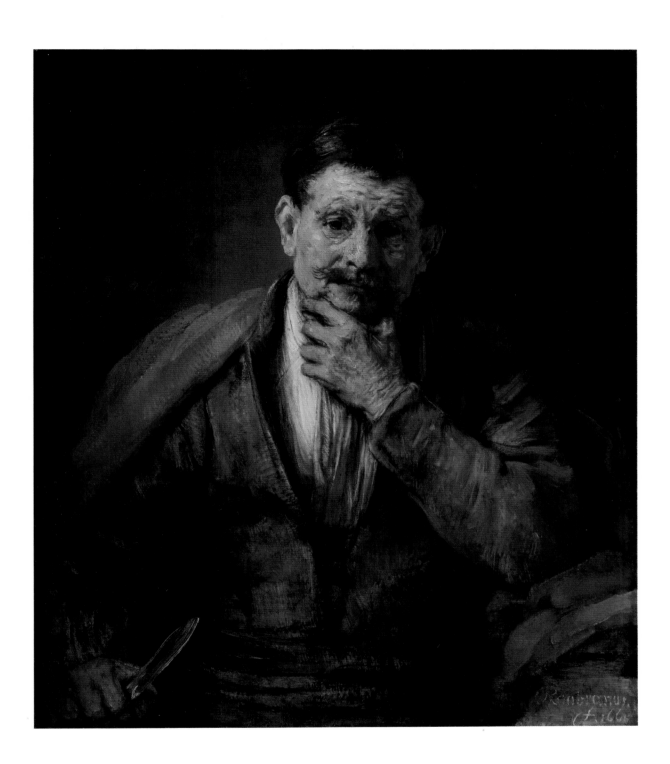

JACOB VAN RUISDAEL

26

DUTCH, 1628/29–1682
Two Water Mills and an Open Sluice, 1653
OIL ON CANVAS
66 × 84.5 cm (26 × 33 ¼ in.)
At bottom left, signed *JVR* [in monogram] *1653*
82.PA.18

Since the seventeenth century Jacob van Ruisdael has been recognized as the Low Countries' most important landscape painter and is credited with transforming the tradition of landscape painting into one based more closely on the observation of natural detail. He had already established his reputation at the age of nineteen, and the present painting, executed when he was scarcely twenty-five, is a strong indication of how rapidly his style matured.

During the early 1650s Ruisdael made a trip to Westphalia (located in present-day Germany), as far as is known the longest trip he ever made from his hometown of Haarlem. En route, he apparently saw some water mills at Singraven, a town in the Dutch province of Overijssel. Subsequently, he painted a series of views of these mills; the Museum's canvas is one of six known variations and the only one that is dated. A comparison of the six versions reveals that the artist did not hesitate to rearrange the setting and some details of the mills in order to enhance his composition. While the general appearance of the rough buildings remained the same, Ruisdael felt free to add small sheds on the side or to alter the shape of the roof and give it a different profile. Similarly, he moved trees around and added hills—such as the one at the right between the two mills in the Museum's landscape—to lend variety to the topography, which in reality was flat. Ruisdael preferred this way of working during this phase of his career, and although his views are topographically accurate in many respects and indicate a close study of nature, he did not consider himself bound to represent every landscape element exactly as it would have appeared.

Later in life he helped satisfy the popular demand for more exotic landscapes by painting views of waterfalls—evidently inspired by paintings and drawings of Scandinavia. These works drew more heavily upon the artist's imagination. Initially, however, he felt relatively more constrained to paint what he saw. The Museum's painting is a rendering of one of the few sites where Ruisdael might have actually seen rushing water. It is a marvelously atmospheric depiction, which the artist made even more lively with his skillful brushwork.
BF

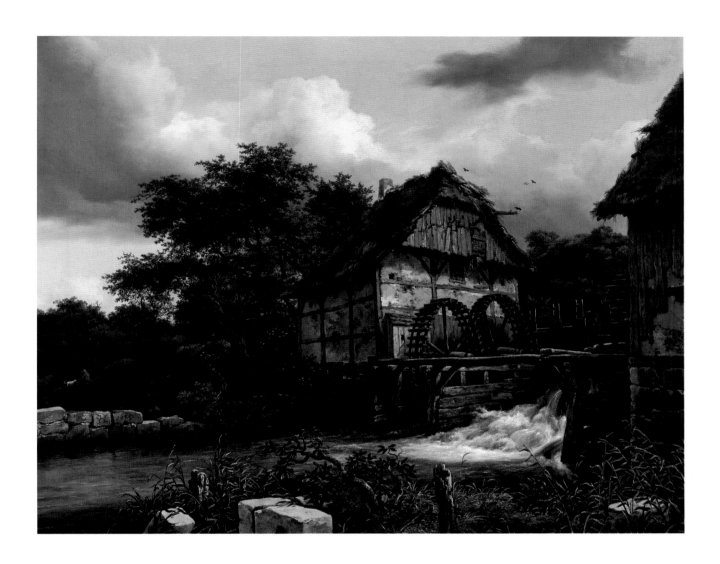

Pieter de Hooch

27

Dutch, 1629–1684
A Woman Preparing Bread and Butter for a Boy, circa 1660–1663
OIL ON CANVAS
68.3 × 53 cm (26 ⅞ × 20 ⅞ in.)
On foot warmer, signed *P. de hooch*
84.PA.47

The education of children became an important issue in Protestant countries during the seventeenth century, and the Dutch public was the first to succeed in establishing a universal education system. The Dutch were proud of their schools, and already in the late sixteenth century, foreigners were aware that the Dutch were teaching even farmers and peasants to read and write. Dutch paintings are full of references to the proper manner in which to bring up children, and compositions that appear to us to be simple depictions of domestic life are often also intended to instill a correct attitude toward child-rearing.

The present painting depicts a mother buttering bread while her young son stands next to her saying grace, an obligatory prayer for children that is often depicted in paintings. He is apparently about to depart for his school, which can be seen across the street labeled with a sign reading *schole*. A major theme of the painting would therefore seem to be the correct behavior and education of a boy from the middle class.

The presence of a small top lying on the floor in front of the doorway is significant. To the Dutch, tops, which fall idle unless one continually "whips" them, became an emblem for the belief that sparing the rod spoiled the child. To the Protestant way of thinking, too much idleness only led to temptation and vice, and the small top underlines the necessity of sending the boy to school.

The Museum's painting is usually dated between 1660 and 1663, about the time de Hooch moved from Delft to Amsterdam. In his earlier paintings he often included soldiers, and the homes he depicted were modest in their decoration. The interiors he painted, especially after his move, became increasingly lavish and luxurious, perhaps reflecting the higher living standards he encountered in Amsterdam or his acceptance by wealthier patrons. The interior seen here is still relatively simple, but it displays the precision and complex geometry that de Hooch characteristically brought to his compositions, traits that emphasized the rectitude revered by the society in which he worked.

BF

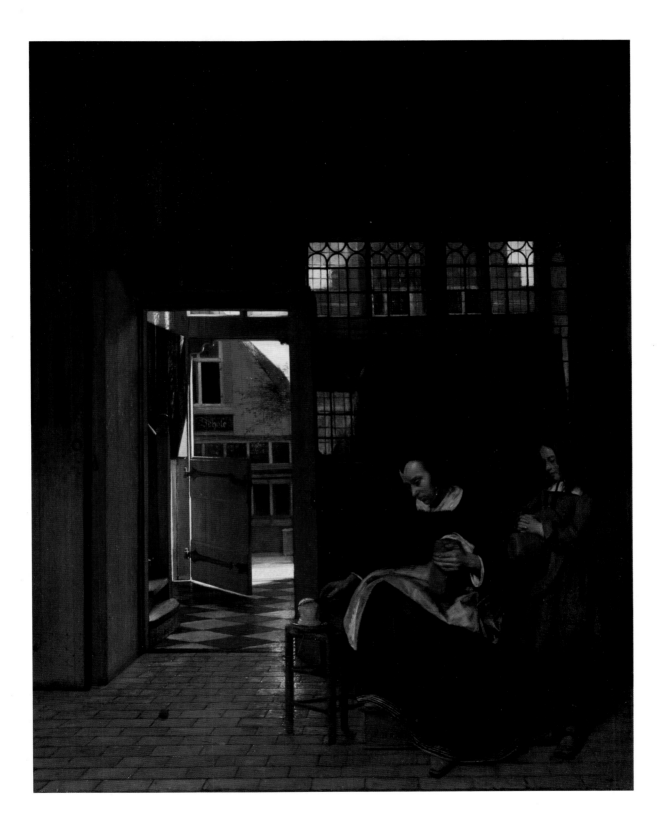

JAN STEEN

28

DUTCH, 1626–1679
The Drawing Lesson, circa 1663
OIL ON PANEL
49.3 × 41 cm (19 ⅜ × 16 ¼ in.)
At bottom left, signed *JStein* [the first two letters in monogram
and the last three letters uncertain]
83.PB.388

The Drawing Lesson appears to be, at least on one level, a touching family scene. An artist, who bears a strong resemblance to known portraits of Jan Steen, demonstrates drawing to a young boy and a teenage girl. It has been suggested that these are Steen's own children, Cornelius and Eva. The painting also presents an unusually detailed view of an artist's studio. On the table are brushes, pens, and charcoal pencils. Hanging over the table's edge is a woodcut by the Dutch artist Jan Lievensz., depicting the head of an old man and dating from about thirty years earlier. Next to the drawing stand is a plaster cast of a male nude, and hanging from the wall, shelf, and ceiling are a number of other plasters. Also on the shelf is a sculpture of an ox, the symbol of Saint Luke, the patron saint of painters (see no. 1). In the background is an easel with a painting on it and a violin hanging on the wall. In the foreground is a stretched canvas, an album of drawings or prints, a carpet, a chest, and other objects that might be used in a still life.

Some of the objects in the foreground—a laurel wreath, a skull, wine, a fur muff, a book, a lute, and a pipe—are related to the traditional theme of *vanitas* (vanity), which is often found in Dutch still lifes. Steen did not paint still lifes as such, and the grouping together of so many of these objects suggests that their presence is more than accidental. In fact, he is most famous for his depictions of human foibles and misconduct and often portrayed himself and others as drinkers or boastful fools. He rarely failed to point out the vanity of this behavior, however. The accumulation of so many traditional symbols of worldly conceit in *The Drawing Lesson* may indicate that Steen felt the artist's role at least in part to be that of a social commentator. The Museum's painting becomes, therefore, a kind of allegory of his own profession.

The Drawing Lesson has survived to this day in remarkable condition. It is rare for a panel painting to have escaped drastic and damaging cleanings, and the detail and subtleties of this composition, which are present to a degree rarely found in the artist's work, are all very much intact.

BF

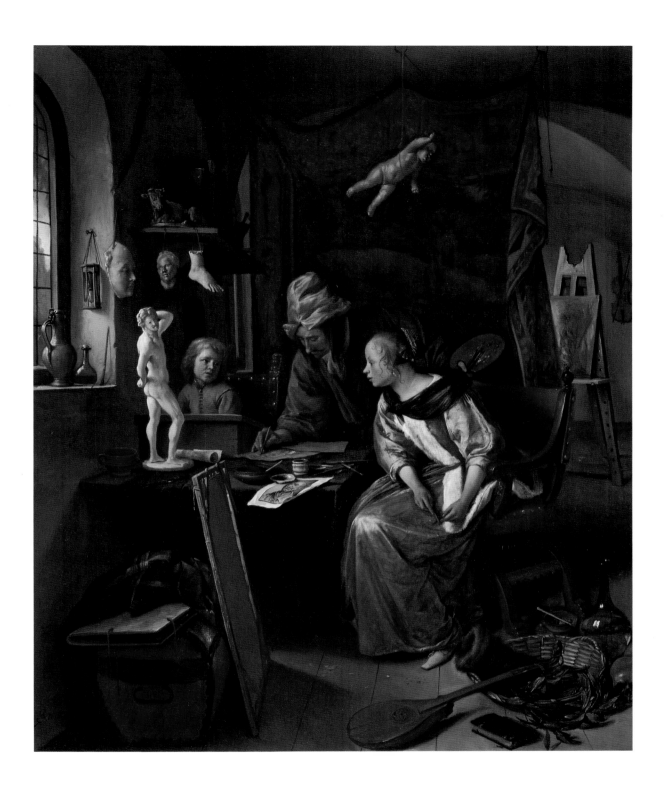

JAN VAN HUYSUM

DUTCH, 1682–1749
Vase of Flowers, 1722
OIL ON PANEL
79.5 × 61 cm (31 ¼ × 24 in.)
On ledge, signed *JAN VAN HUYSUM FECIT 1722*
82.PB.70

Perhaps more than any other artist, Jan van Huysum reflects the Dutch fascination with nature and its myriad details. He worked at a time when the Dutch republic was already past its so-called golden age and had acquired the sophisticated taste and love of embellishment that we associate with the Rococo period in France. Van Huysum's work reflects this change in taste while retaining a fidelity to subject matter that was part of an established Dutch tradition.

Van Huysum invariably included many different kinds of flowers in his pictures, often recently bred or newly acquired specimens brought to him by Amsterdam's avid flower collectors. Enormous sums of money were spent on flowers at the time, and the circle of connoisseurs surrounding van Huysum could well appreciate his ability to depict them so exactly. The details of his highly finished technique were a jealously guarded secret.

The composition of *Vase of Flowers* is relatively straightforward. The vase is centrally placed with no more background than a slanting ray of light, which sets off the bouquet. Another van Huysum painting in the Museum's collection, which depicts both flowers and fruit, is also dated 1722 and may be a companion piece. The second picture, however, is composed asymmetrically; fruit flows over the ledge upon which it has been placed, some of the grapes and the pomegranate are already bursting and overripe. Although these features may simply be intended to evoke a luxurious standard of living, they may also be meant to contrast with the unspoiled quality of *Vase of Flowers*.

BF

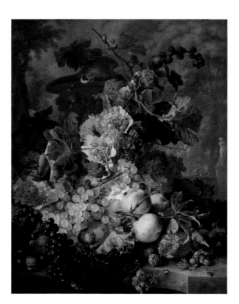

JAN VAN HUYSUM. *Fruit Piece*, 1722, OIL ON PANEL.
79.5 × 61 cm (31 ¼ × 24 in.). 82.PB.71.

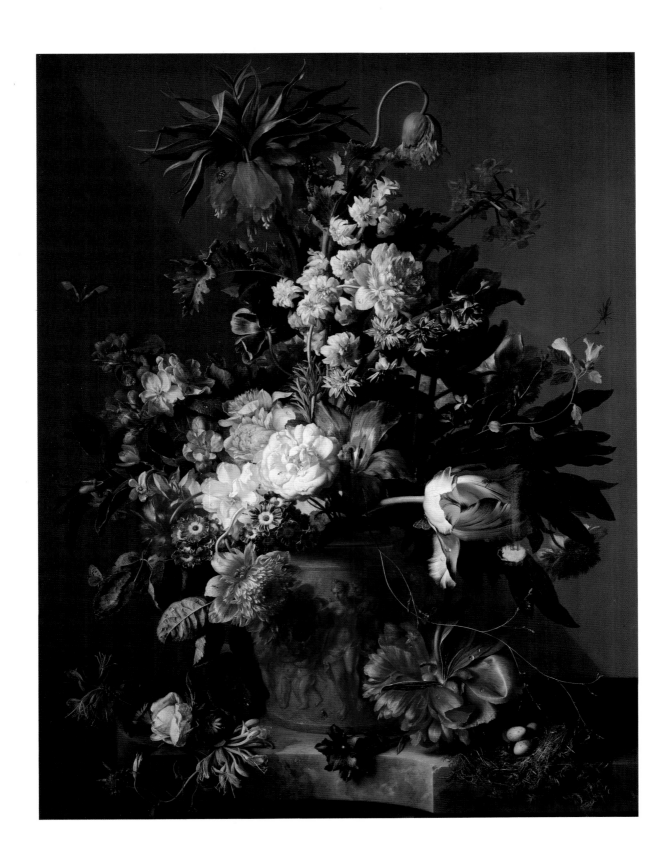

VINCENT VAN GOGH

DUTCH, 1853–1890

Irises, 1889

OIL ON CANVAS

At lower right, signed *Vincent*

71 × 93 cm (28 × 36 ⅝ in.)

90.PA.20

The episodes of self-mutilation and hospitalization that followed his quarrel with Paul Gauguin finally prompted van Gogh to have himself admitted in May of 1889 to the asylum Saint-Paul-de-Mausole in Saint-Rémy de Provence. Despite occasional, disturbing recurrences, van Gogh produced almost 130 paintings during his year of recuperation in Saint-Rémy. Although he was not permitted to leave the grounds for the first month, the overgrown and somewhat untended garden of the asylum provided ample material for his paintings, which he worked, as was his practice, directly from life. In the first week van Gogh reported to his brother Theo that he had begun work on "some violet irises."

That van Gogh was deeply affected by the regenerative powers of nature comes across clearly even in this limited view. There is a muscularity to the blue-violet blooms supported on their sturdy stems amid swaying, pointy-tipped leaves that almost forcefully push their way through the red earth. Even the contemporary critic Félix Fénéon described the *Irises* in anthropomorphic terms, although he saw destruction rather than renewal in the image: "The 'Irises' violently slash into long strips, their violet petals on sword-like leaves."

Incorporating lessons learned from Pointillist color theory, Impressionist subject matter, and Japanese woodblock printmakers, van Gogh distills the garden patch into patterned areas of vivid color. The composition, with its raised impastoed brushwork intact and unfaded, is bissected horizontally by waving bands of cool green leaves. Above, the varied clumps of violet petals (set off by a lone white iris) are placed in contrast over the warm green ground of the distant, sunlit meadow. Below, the same violet shades reverberate in juxtaposition with the red-brown of the Provençal dirt, built up with striated parallel brushstrokes.

It was most likely the cropped nature of the composition that led van Gogh to describe the Getty canvas in a letter to his brother as a study after nature rather than a finished painting. Nevertheless, among the eleven canvases he received in July, Theo chose only the *Irises* to accompany the earlier *Starry Night* (New York, Museum of Modern Art) as van Gogh's submission to the Salon des Indépendants in September 1889.

PS

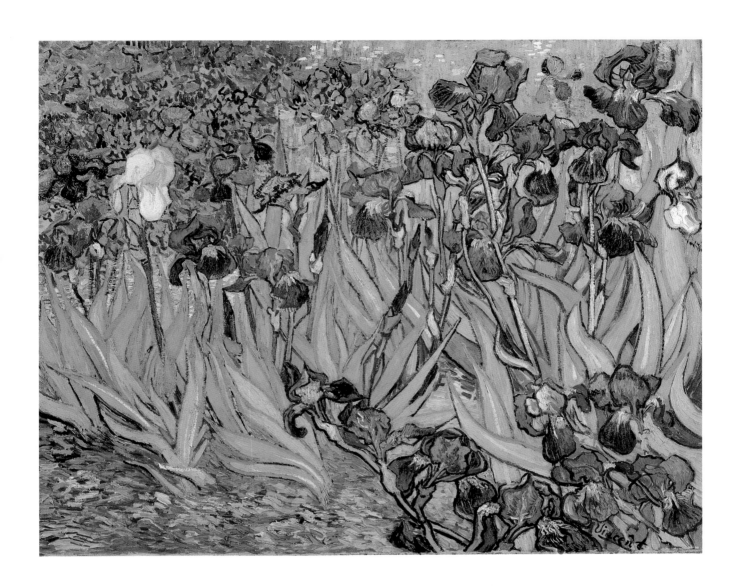

GEORGES DE LA TOUR

FRENCH, 1593–1652
The Beggars' Brawl, circa 1625–1630
OIL ON CANVAS
84 × 138.5 cm (33 × 54 ½ in.)
72.PA.28

The subject of *The Beggars' Brawl* is the fight of two elderly itinerant musicians over a place to play their instruments. The man on the left, who wears a hurdy-gurdy slung around his shoulders, is defending himself with a knife and the crank of his instrument. He is menaced by another man who seems to be hitting him with a shawm, a kind of oboe, and who wears a second similar instrument at his waist. In his upraised hand the second beggar holds a lemon and squeezes its juice into his opponent's eyes. This is done either to test whether the man with the hurdy-gurdy is truly blind or simply to further agitate him. On the left an old woman seems to implore someone to help. At the right two more itinerants, one with a violin and the other with a bagpipe, enjoy the fight.

The subject is a rare one; many seventeenth-century artists painted peasants or musicians, but depictions of quarrels among them are hardly ever found. One of the few examples is a print by the French artist Jacques Bellange that may have supplied the inspiration for the Museum's painting. La Tour used motifs from Bellange's prints on other occasions and obviously admired him.

La Tour spent his life in Lorraine in eastern France and is not known to have ventured far from there. His style therefore is based upon whatever works he might have seen in or near the relatively small city of Lunéville where he lived, and it is not surprising that prints should have been a major source of his inspiration. The violinist on the right in the Museum's painting may in fact be derived from a print by the Dutch artist Hendrick ter Brugghen (see no. 22), which depicts a grinning man in a striped coat holding a violin and wearing a feathered cap. The print probably dates from the mid-to-late 1620s, as does La Tour's painting.

In a more general way La Tour's work belongs to the realist tradition that swept Europe in the aftermath of the very revolutionary pictures painted by Caravaggio in Italy (see no. 20). It is doubtful that La Tour ever saw any original paintings by Caravaggio, but the desire for a renewal of naturalism in painting was so strong that it quickly found adherents everywhere.

BF

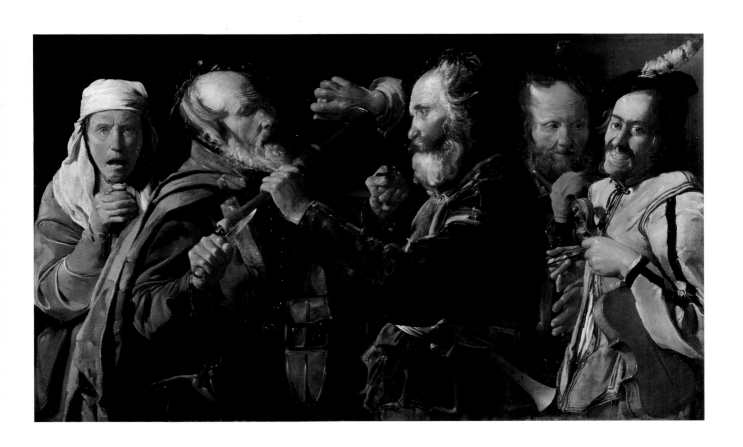

NICOLAS POUSSIN

FRENCH, 1594–1665
The Holy Family, 1651
OIL ON CANVAS
96.5 × 133 cm (38 × 52 ⅜ in.)
81.PA.43 owned jointly with the Norton Simon Museum

Of the many foreign artists who worked in Rome, Poussin was probably the most famous. Even in his own time, he was revered as a master. Like Valentin before him, Poussin spent nearly his entire adult life in the papal city. The contemporary Italian biographer Bellori wrote: "France was his loving mother, and Italy his teacher and second fatherland." The artist drew inspiration from his Roman surroundings and became the fountainhead of the classical tradition in seventeenth-century Italy, profoundly influencing the art not just of his adopted land but all of Europe.

Later in life, Poussin painted a large number of religious themes, in particular several depicting the Holy Family. The Museum's painting, probably the most beautiful and ambitious of these works, includes Christ and his immediate family as well as the infant John and his mother, Elizabeth. The action focuses on the embrace of John and Jesus; the ewer, towel, and basin of water held by the group of putti (infant boys) at the right may refer to the bathing of the child or to John's later baptism of Christ.

The painting is composed in a highly classicizing vein and exemplifies Poussin's very rationalistic inclination. He often placed figures in a setting so meticulously composed that it seems to have a geometric underpinning. In contrast to the "realism" of the Caravaggesque painters (see no. 20), whose popularity had faded by this time, Poussin normally used fairly strong color and placed his subjects in idyllic settings bathed in bright light. The figures hark back to those of Raphael (1480–1520), the model for most classicizing artists of later centuries, and the landscape derives from the Venetian tradition of Giorgione (circa 1476–1510) and Titian (circa 1480–1576).

The Museum's painting was commissioned in 1651 by Charles III de Blanchefort, duc de Créqui, one of the many wealthy patrons who competed for Poussin's pictures. The duke's grandfather was the French ambassador to Rome under Louis XIII, the first Frenchman to have bought a work from Poussin and an important figure in spreading the artist's reputation in France. Continuing the tradition, the duc de Créqui, who was himself to be appointed ambassador to Rome under Louis XIV, became one of Poussin's most important collectors.

BF

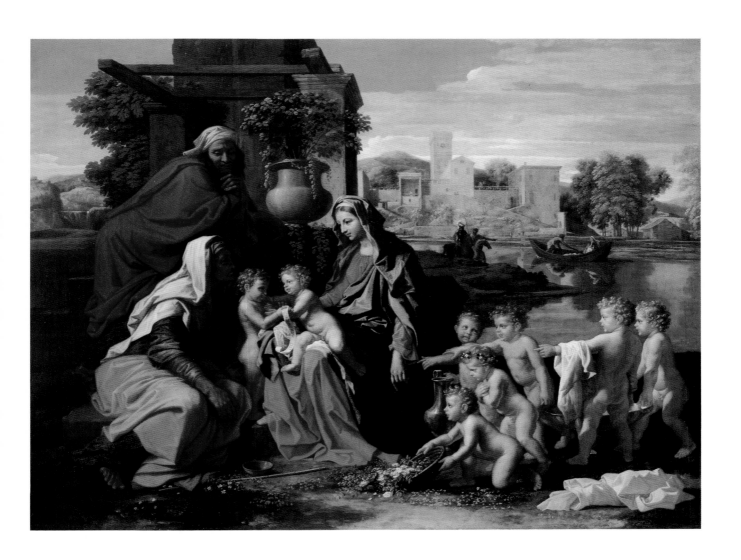

JEAN-FRANÇOIS DE TROY

33

FRENCH, 1679–1752
Before the Ball (La Toilette pour le Bal), circa 1735
OIL ON CANVAS
81.8 × 65 cm (32 ⅜ × 25 ⁹⁄₁₆ in.)
At bottom right, signed *De Troy 1735*
84.PA.668

De Troy was one of eighteenth-century France's most versatile artists. The son of a well-known portrait painter, he came to excel not only in that field but also in the painting of historical, mythological, and religious subjects. In addition, he designed tapestries and decorations for the royal residences at Versailles and Fountainebleu. He worked successfully in both large and small scale, and his works, like those of Watteau (1684–1721), vividly convey the elegance and sophistication characteristic of fashionable Parisian society of the time.

The Museum's painting, along with its companion piece, *Le Retour du Bal (The Return from the Ball*; now lost, but known from an engraving), was painted around 1735 for Germain-Louis de Chauvelin, the minister of foreign affairs and keeper of the seal under Louis xv. Evidently, Chauvelin was dismissed from his post before the paintings could be delivered. De Troy therefore retained possession and exhibited them in the Salon of 1737. At the time, the pair were declared to be the artist's finest works.

Before the Ball typifies de Troy's *tableaux de mode*, depictions of the aristocratic class at home and at leisure. These paintings are now considered to be among the most significant of the artist's works. In the Museum's painting a group of men and women watch a maid put the final touches on her mistress's hair. The onlookers are already wrapped in cloaks and hold masks in eager anticipation of the evening's festivities. The richly appointed room is decorated with wall brackets and furniture in the current style. The now-lost companion piece presented the same group removing their capes and masks upon their return from the ball.

At the time, some critics disapproved of the life-style celebrated by such paintings, but de Troy apparently moved easily in fashionable circles and does not appear to have been moralizing about the vanity of the aristocratic behavior. On the contrary, he seems to have relished it and to have well understood its nuances and conventions. He has succeeded in capturing the slightly charged and even erotic climate of the proceedings, and there is a certain realism in his observation that betokens a clear and acutely perceptive eye.

BF

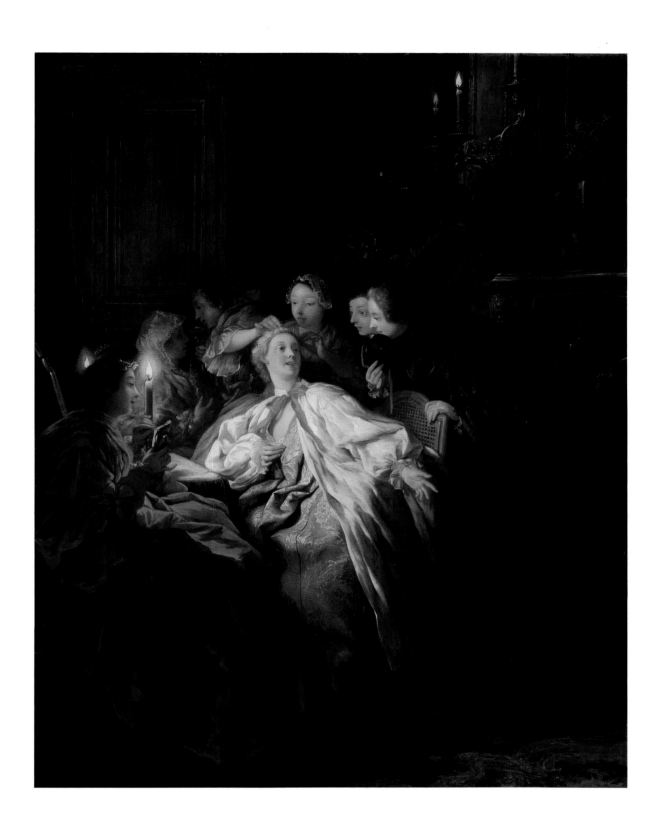

Jean-Baptiste Greuze

34

French, 1725–1805

The Laundress (La Blanchisseuse), 1761

OIL ON CANVAS

40.6 × 31.7 cm (16 × 12 ⅞ in.)

83.PA.387

During the last half of the eighteenth century, Greuze was the most famous and successful exponent of genre painting in France. He normally chose themes with strong moralistic overtones, the closest parallels to which were to be found in the contemporary theater rather than in the work of his fellow artists. At a time when the academies extolled the depiction of historical themes as the highest form of painting, Greuze attempted to raise his more mundane subject matter to a comparable level of importance.

Like other French artists before him, Greuze was inspired by the study of the seventeenth-century Dutch and Flemish pictures that were extensively collected and admired in France during the eighteenth century. Many of his subjects are in fact taken directly from the works of Dutch and Flemish artists, who were the first to concentrate on depictions of working people and servants. In the 1730s the French artist Chardin had painted a similar laundress, and Greuze was no doubt familiar with his picture. Chardin emphasized the humility and quiet dignity of his subject, but Greuze chose to give his laundress a provocative glance and to stress her disheveled appearance. By exposing her ankle and foot, the artist imparted a suggestion of licentiousness to the young woman. Through further details of her clothing and the disorderly setting—details that would have been much more readily interpreted by his contemporaries than by modern viewers—he further attempted to warn against the girl's tempting glance.

The Laundress was exhibited in the Salon of 1761, the year Greuze first achieved success, and the critic Denis Diderot, one of the artist's first prominent admirers, described the girl in the painting as "charming, but . . . a rascal I wouldn't trust an inch." Soon after its first exhibition, the Museum's painting was acquired by the collector Ange Laurent de La Live de Jully, the artist's most important patron during this period.

BF

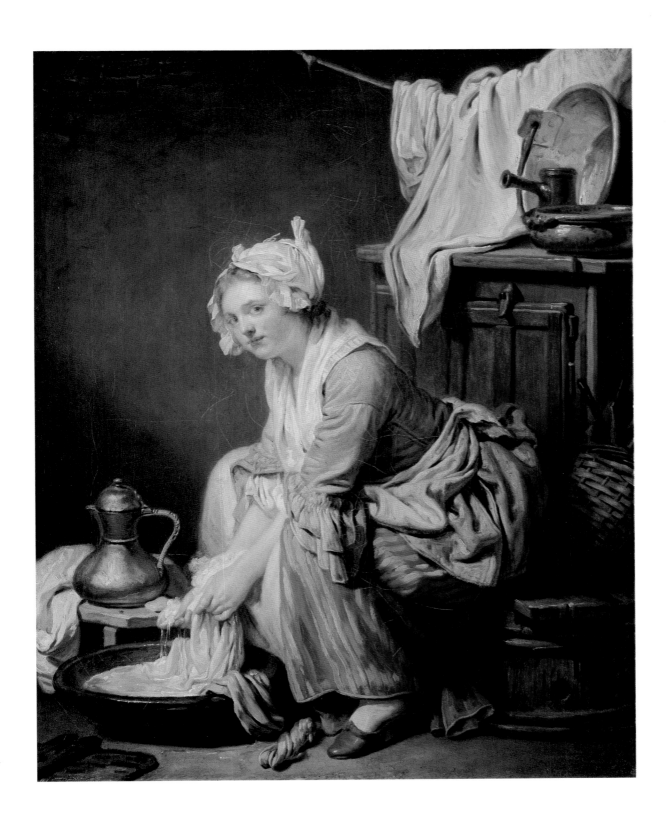

THÉODORE GERICAULT

35 FRENCH, 1791–1824
Portrait Study, circa 1818–1819
OIL ON CANVAS
46.5 × 38 cm (18¼ × 15 in.)
85.PA.407

Portraits played a relatively small part in Gericault's career, and he is best known as a painter of heroic or historical subjects. The present picture, however, clearly demonstrates that he was capable of capturing a sitter's character with great sympathy and spontaneity. The portrait is obviously the study of a model, not a commissioned work, and Gericault probably chose this subject for his extraordinary face.

The artist is known to have sympathized with the cause of abolitionism and often included black figures in his pictures, sometimes in heroic roles. His portrayal of black subjects was influenced in part by stories of the wars the French army had fought with black insurgents in Haiti during the first years of the century. He must also have known blacks from North Africa and shared the fascination with exotic cultures that characterized the work of many nineteenth-century French artists. Gericault and many of his contemporaries saw the black man in a romantic light, attributing to him an unspoiled nobility that more "civilized" Europeans could not attain. The same "primitive" innocence was frequently attributed to the American Indian.

It is generally thought that the sitter in the Museum's portrait was a certain Joseph—his family name is not recorded—who came from Santo Domingo in the Caribbean and worked initially in France as an acrobat and then as a model. He acquired some fame in Paris because of his considerable physical beauty, wide shoulders, and slender torso. Gericault used Joseph for a great many studies, mostly drawings, and as the principal figure in his most famous work, *The Raft of the Medusa* (1819; Musée du Louvre, Paris). The sitter in the Museum's painting looks a bit old to have been used for such a dramatic pose, however, and therefore may not be the same model. The many studies of Joseph that are most obviously related to the finished *Raft of the Medusa* do not include the mustache and slightly sad features of the Museum's portrait. Nevertheless, the latter is assumed to belong to the period of 1818 to 1819 when Gericault was most preoccupied with *The Raft of the Medusa*, which ultimately included three black figures.

BF

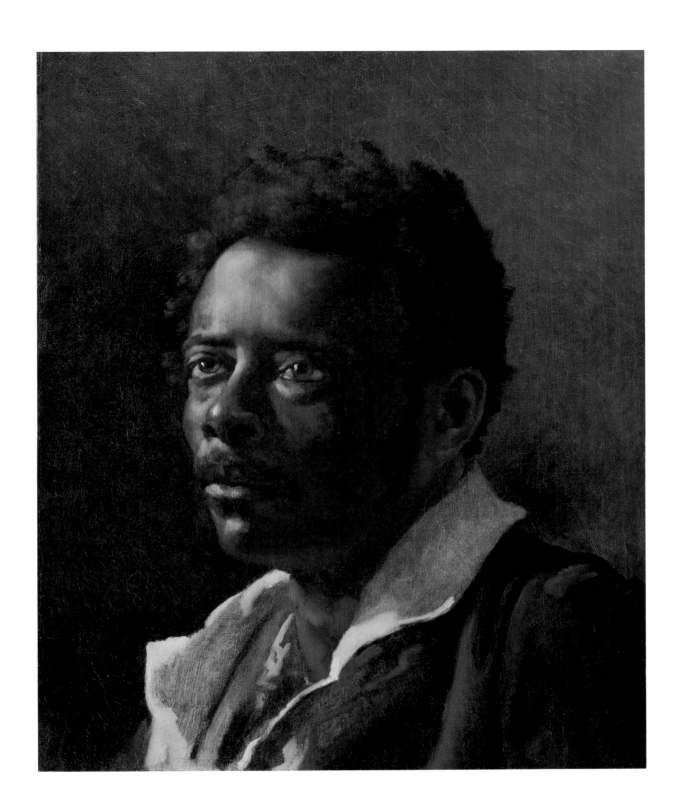

Jacques-Louis David

French, 1748–1825
The Farewell of Telemachus and Eucharis, 1818
OIL ON CANVAS
87.2 × 103 cm (34 ½ × 40 ½ in.)
On quiver, signed *DAVID*, and, on horn, dated *BRUX 1818*
87.PA.27

As the most prominent painter of revolutionary Paris, and later the favorite painter of Napoleon, David had little choice but to leave the country after the reinstatement of the French monarchy in 1815. The final decade of his life, spent in voluntary exile in Brussels, was marked by a transition of style and subject. His output during this time consisted of intimate half-length portraits, often of fellow exiles, as in the case of the Museum's other work by the artist (*Zénaïde and Charlotte Bonaparte*), as well as an innovative series of mythological paintings, several of which (including the present work) deal with themes of erotic entanglement.

The Farewell of Telemachus and Eucharis was probably inspired by Fénelon's moralizing romance, *Les Aventures de Télémaque* (1699), which in turn draws its characters from Homer's *Odyssey*. Telemachus, the son of Ulysses and Penelope, is passionately but chastely in love with Eucharis, one of Calypso's nymphs. However, filial duty dictates that the youth must depart.

David sets this intimate farewell in a secluded grotto. In spite of the antiquity of the subject, the partially-clad figures are given a great immediacy by the half-length format and specificity of features. Telemachus in particular has a portrait-like air—his dreamy, adolescent expression seemingly already focused on his departure—even while his hand continues to grip the nymph's thigh. Eucharis, by contrast, buries her face in resignation, her arms encircling Telemachus's neck in mute protest of an inevitable leavetaking. The contrast of masculine rectitude with feminine emotion is a current that runs throughout David's oeuvre. The excellent state of preservation of this unlined canvas highlights the sophisticated color harmonies characteristic of David's late period.

Telemachus was commissioned by Count Erwin von Schönborn, vice president of the States General of Bavaria. Later that year, he commissioned a pendant from David's most devoted student, Antoine-Jean Gros. Lacking the *Telemachus*'s themes of duty and chastity, Baron Gros's *Bacchus and Ariadne* (Phoenix Art Museum) turns up the erotic heat a notch while moving away from the carefully crafted linearity of the Neoclassical style as perfected by David.

PS

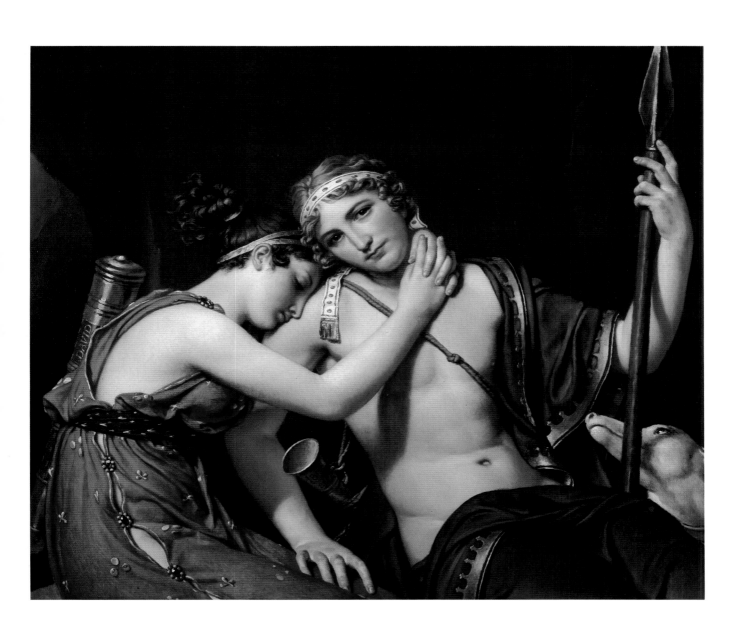

JACQUES-LOUIS DAVID

FRENCH, 1748–1825

The Sisters Zénaïde and Charlotte Bonaparte, 1821

OIL ON CANVAS

129.5 × 100 cm (51 × 39 ⅜ in.)

At bottom right, signed *L. DAVID./BRVX. 1821*

86.PA.740

David was the artist closest to the Napoleonic government from its inception, and he was commissioned to paint its most important events. His enthusiastic espousal of an art based on antique models was matched by Napoleon's desire to emulate Greco-Roman civilization and principles. Both men played essential roles in the development of Neoclassicism, and the style thus created dominated Europe for nearly a half-century after the fall of the Napoleonic Empire. By the time the Museum's picture was painted, however, the French monarchy had been reestablished. Although David could have returned to France, he had decided to remain in exile and was living in Brussels.

The sitters of this double portrait are the daughters of Napoleon's older brother, Joseph Bonaparte (1768–1844). A key figure of the Napoleonic era, Joseph was made king of Naples and Spain at the height of France's aggressive expansion. After Napoleon's final abdication in 1815, Joseph went into exile in the United States, settling near Philadelphia in Bordentown, New Jersey. His family remained in Europe, however, and for a time resided in Brussels.

On the left of the painting is nineteen-year-old Charlotte, dressed in gray-blue silk. She wished to become an artist and received drawing lessons from David, with whom she maintained a friendly relationship. On the right, dressed in deep blue velvet, is Zénaïde Julie, age twenty, who later became a writer and translator of Schiller, the German poet and dramatist. The sisters are depicted wearing tiaras and seated on a couch decorated with bees, the Bonaparte family emblem. As they embrace, Zénaïde holds out a letter from their father on which a few words can be deciphered as well as the information that it was sent from Philadelphia.

The portrait exhibits some of the trappings of imperial fashion, notably the couch in the Roman manner and the high waistlines of the gowns; yet it is no longer as severe and solemn as many of the artist's earlier works, and there is a sense of warmth and informality that perhaps signals a lessening of David's earlier idealistic fervor. The fabrics are rendered with great sensitivity, and the portrait, no doubt commissioned by the exiled Joseph Bonaparte, conveys a sympathetic charm that apparently survived in the face of the family's unhappy circumstances.

BF

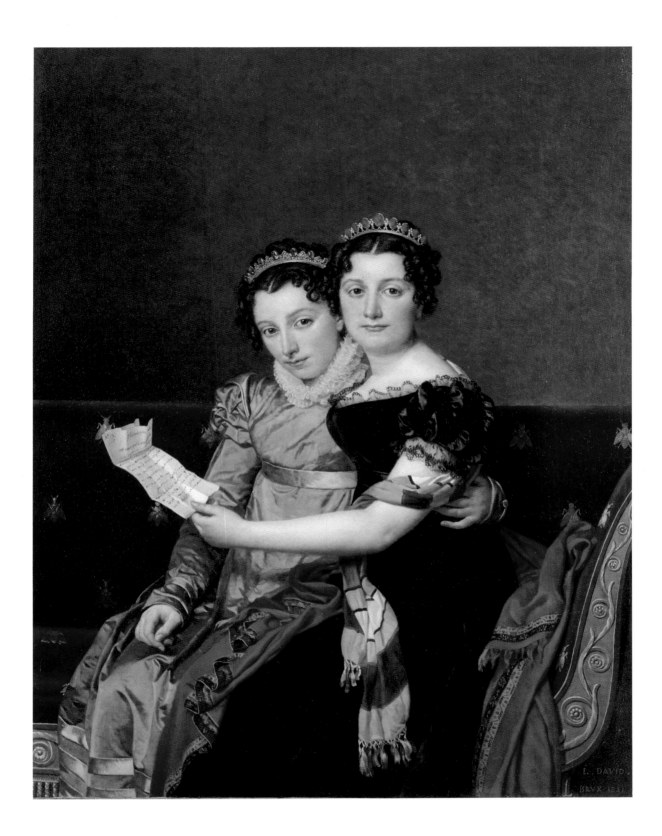

JEAN-FRANÇOIS MILLET

FRENCH, 1814–1875
Man with a Hoe, 1860–1862
OIL ON CANVAS
80 × 99 cm (31 ½ × 39 in.)
At bottom right, signed *J. F. MILLET*
85.PA.114

38

The French revolutions of 1830 and 1848 gave rise to numerous liberal movements intent upon correcting social ills, and a widespread belief existed among reformers that painting should reflect these concerns rather than portray figures with classical associations. Although Millet was not a social reformer, his personal convictions caused him to align himself with the reformers.

A religious fatalist, Millet believed that man was condemned to bear his burdens with little hope of improvement. He wanted to show the nobility of work in his art, and to this end, he concentrated his attention on peasants and farm laborers. The Industrial Revolution had caused a steady depopulation of farms, and a painting such as *Man with a Hoe* was meant to show the farmer's perseverance in the face of unrelieved drudgery. In the distance a productive field is being worked, but the back-breaking task of turning the rocky, thistle-ridden earth must precede this.

Millet's painting was criticized for the especially brutish image of the peasant. Of all the laborers depicted by Millet, this farmer is the most wretched. He has been brutalized by his work, and his image understandably frightened the Parisian bourgeoisie. Millet may have been making a reference to Christ's Passion because at the time the thistles were widely interpreted as referring to the crown of thorns. The face of the peasant, however, did not fit the then-popular conception of Christ. *Man with a Hoe*, in any event, was considered a symbol of the laboring class for many decades and in 1899 was immortalized by the socialist poet Edwin Markham in a poem of the same name in which he rhetorically asked, "Whose breath blew out the light within this brain?"

During and after its public exhibition in the Salon of 1863, *Man with a Hoe* was attacked by critics for its supposed radicalism, and Millet was forced to declare that he was not a socialist or an agitator. Although his attitude pleased neither reformers nor the establishment, his paintings proved to be very popular, particularly in the United States. *Man with a Hoe*, one of his most famous pictures, had been purchased by a San Francisco collector by the turn of the century.

BF

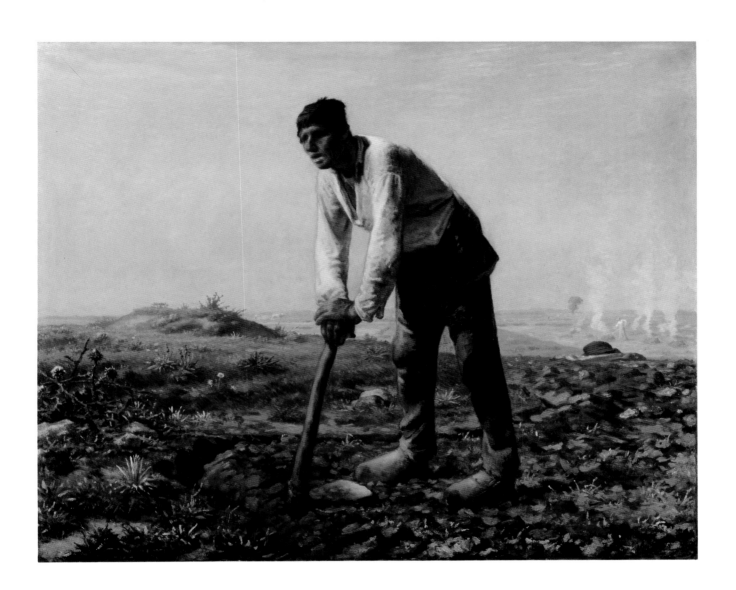

PIERRE-AUGUSTE RENOIR

39

FRENCH, 1841–1919
La Promenade, 1870
OIL ON CANVAS
At lower left, signed *A. Renoir. 70.*
81.3 × 65 cm (32 × 25 ½ in.)
89.PA.41

Renoir was twenty-nine when he painted *La Promenade*, and the member of a close-knit group of young avant-garde artists soon to be fractured by France's declaration of war on Germany. Having spent the previous summer painting out-of-doors alongside Monet in La Grenouillière, Renoir displays in *La Promenade* a shift toward the high-keyed palette characteristic of the recently forged Impressionist style. In this landmark of early Impressionism, Renoir no longer conceives of nature as a backdrop, but rather, by working almost certainly *en plein air*, and by using spontaneous brushwork and all-over dappled light, Renoir fully integrates the figures into their verdant setting.

Themes of dalliance and leisure run throughout Renoir's oeuvre. In contrast with Monet's views of domesticity amidst flowering gardens, nature for Renoir is seen both as a setting for seduction and a metaphor for sensual pleasure. The trysting couple in the Getty canvas is at once completely modern—evocative of the new Parisian middle class, flocking on the weekends to the parks and suburbs—as well as representative of a more long-standing art historical motif, traceable to the amorous couples of Watteau's *fêtes galantes*, where enticement into secluded glades is equated with the stages of seduction.

With his characteristic feathery brushwork, Renoir conveys in *La Promenade* the dappled effect of sunlight filtered through foliage that would become the hallmark of many of his greatest works of the 1870s and 1880s. Deeper in the woods and partially engulfed in shadow, the male figure appears somewhat rustic in comparison to his elegant companion who turns back to gently lift her diaphanous white gown free of the underbrush. She has been variously identified as Rapha, the mistress of Renoir's friend Edmond Maître, and Lise Tréhot, Renoir's own mistress. The latter possibility would suggest the shadowy figure who draws the woman forward is the artist himself, his pictorial role intended as analogous perhaps to that of the painter, drawing the viewer into the illusionistic space of the canvas. Renoir returns to this composition in 1883 for a drawing published in *La Vie Moderne* (December 29) in which the relative positions of the man and woman are reversed, both spatially and in terms of initiative.

PS

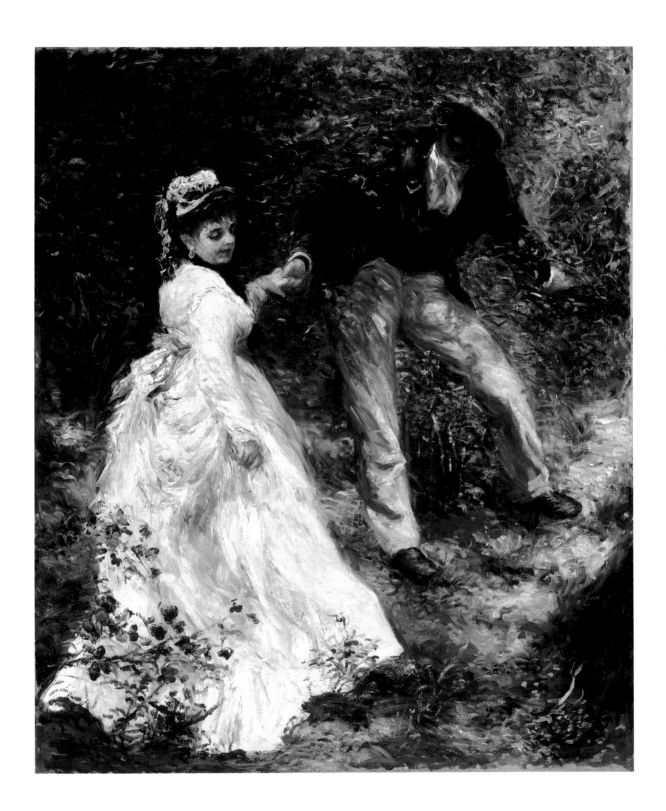

Paul Cézanne

40

French, 1839–1906
Portrait of Antony Valabrègue, circa 1869–1871
OIL ON CANVAS
60 × 50 cm (23 ⅝ × 19 ¾ in.)
85.PA.45

Cézanne did not achieve any measure of public acceptance until the mid-1870s, when he and members of the Impressionist circle—which included Pissarro, Monet, Degas, and Renoir—inaugurated their own exhibitions in Paris. Prior to that time, their work was regularly refused at the annual Salons, and Cézanne's pictures in particular were singled out for scathing criticism. His painting technique was very direct and at times even violent. Although in general it dismayed critics, it inspired admiration from a few like-minded artists; certain writers, especially Cézanne's longtime friend Emile Zola; and even a few art historians, among them the sitter of the present portrait, Antony Valabrègue (1844–1900).

Like Cézanne, Valabrègue was born in Aix-en-Provence in southern France. Throughout the 1860s the two men spent a great deal of time in each other's company and, with Zola, exchanged ideas, poetry, and numerous letters. In spite of this friendship, Valabrègue, who was a critic, journalist, and poet, never wrote anything about Cézanne or his work.

In 1866 Cézanne painted a large portrait of Valabrègue that was rejected by the Salon. It was painted not with brushes but with a palette knife, an instrument the artist favored during this period and that contributed to the harsh, rough appearance of his work. Subsequently, he painted several other portraits of his friend, including the present example, thought to have been executed around 1870.

Valabrègue was apparently a shy and fastidious man, fairly tall and slender in build. The present portrait conveys these characteristics and reveals the artist's increasingly secure sense of form and painterly structure. By this time he had begun using brushes more regularly, and his coloring had become lighter and more optimistic. He also had begun to demonstrate a more reflective and analytical stance toward his work that would ultimately lead him to turn increasingly to landscapes and still lifes. The Museum's portrait shows Cézanne midway in this transition, boldly rendering his friend in thick strokes of color but already restraining his own impetuous side in favor of a more serious examination of form.
BF

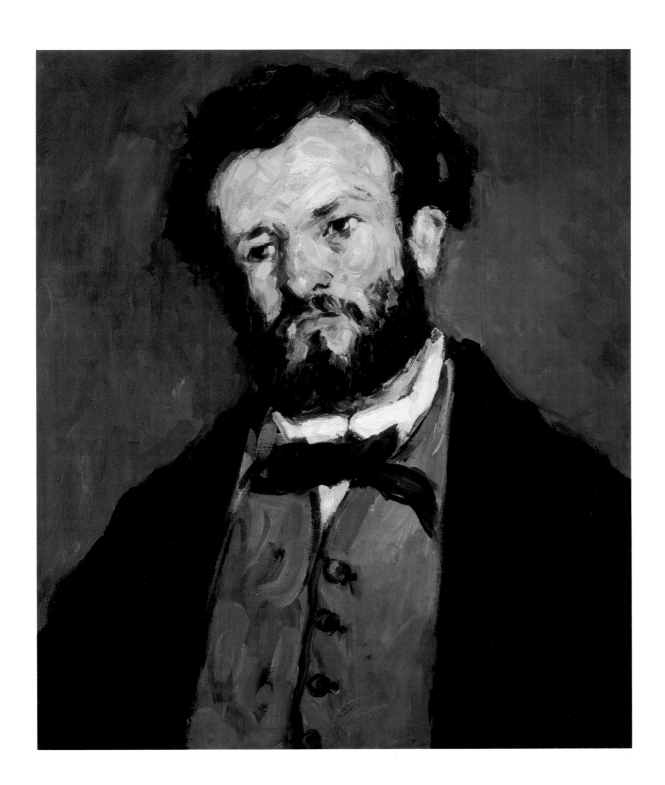

EDOUARD MANET

41

FRENCH, 1832–1883

The Rue Mosnier with Flags (La rue Mosnier aux drapeaux), 1878

OIL ON CANVAS

At lower left, signed *Manet 1878*

65.5 × 81 cm (25 ¾ × 31 ¾ in.)

89.PA.71

Although his influence was strongly felt among the Impressionists, Manet never officially joined their ranks. He did share with them, however, the ideal voiced by poet and critic Charles Baudelaire: the commitment to depict modern Paris. The Getty canvas represents rue Mosnier (now rue de Berne) as seen from the window of Manet's second floor studio on the afternoon of June 30, 1878, a national holiday. The first official celebration organized by the Third Republic, the *Fête de la Paix*, was intended to mark the success of the recent Exposition Universelle and to commemorate France's recovery from the disastrous Franco-Prussian War of 1870–1871 and the bloody Commune that followed.

In the upper portion of the canvas, hansom cabs pull to the side of the street to load and unload their elegant passengers. The artist uses the cool tonalities of the recently constructed, prosperous street as a pale backdrop for the sparkling daubs of red, white, and blue paint; the staccato repetition of the French *tricolore* on a bright, gusty day summons up a sense of patriotic fervor that is reinforced by the apparent speed of the fluid brushwork.

Counterbalancing this distant glittering bustle, the emptiness of the street in the foreground is punctuated only by two solitary figures, neither one participating in the celebration. A worker carrying a ladder is radically cropped by the lower edge of the composition. Further on, an amputee, perhaps a war veteran, wears the blue blouse and *casquette* of a Parisian laborer; his back to the viewer, this hunched figure makes slow progress on his crutches. A shabby fence to the left attempts to conceal a yard of rubble created by nearby railroad construction. Considered as a whole, *La rue Mosnier* presents a view of national pride and newfound prosperity tempered by a sensitivity to the associated costs and sacrifices.

Perhaps earlier the same day, Manet depicted the same view in a sketchier, less highly finished version (Zürich, Bührle collection). Claude Monet also painted two street scenes on June 30, one of rue Montorgeuil and one of rue Saint-Denis. In contrast to Manet's somewhat ironic observations on the government-organized festivities, Monet's colorful use of all-over broken brushwork suggests an urban patriotic spectacle at once euphoric and impersonal.

PS

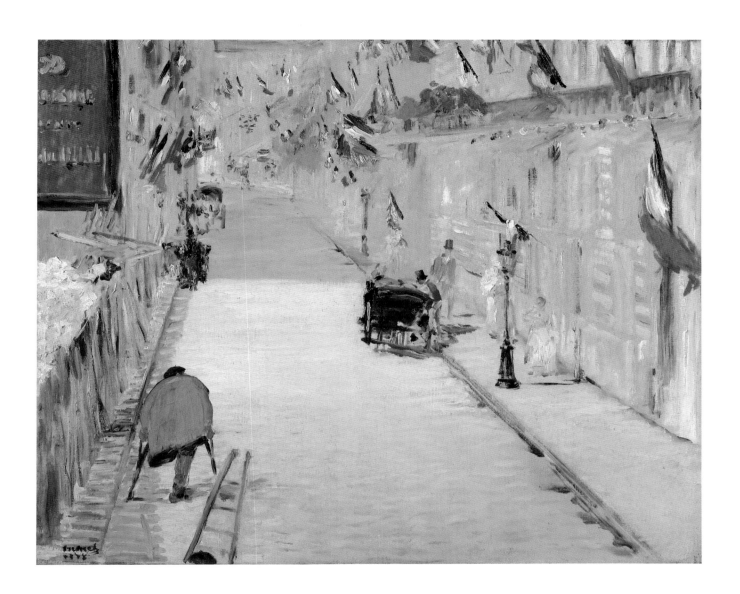

EDGAR DEGAS

FRENCH, 1834–1917

Waiting (L'Attente), circa 1882

PASTEL ON PAPER

48.2 × 61 cm (19 × 24 in.)

At top left, signed *Degas*

83.GG.219 owned jointly with the Norton Simon Museum

Degas, like many French artists at the middle of the nineteenth century, concentrated on representing the various facets of Parisian daily life. He treated both mundane and fashionable subjects ranging from women washing and ironing to the occupations of musicians and jockeys. The single most common theme in Degas's long career, however, was the ballet. Hundreds of his paintings and drawings depict many aspects of the dancer's art. He is credited with once remarking that the dance was only "a pretext for painting pretty costumes and representing movements," but his work belies this somewhat flippant observation. Degas knew many of his dancers very well and never portrayed their male counterparts. This would suggest that they were more to him than simply a vehicle for the treatment of color or composition.

Although the ballets that were regularly performed at the Opéra in Paris were rarely classical, Degas depicted his dancers wearing traditional costumes or rehearsal garments. Conservative by nature, he was appreciative of older customs. Just as his paintings often harken back to Renaissance examples for their inspiration, so the classical ballet signified for him the art of ancient Greece. The American collector Louisine Havemeyer— who formerly owned the Museum's picture—is supposed to have inquired of the artist why he painted so many dancers; he replied that ballet was "all that is left us of the combined movements of the Greeks." Somewhat paradoxically, however, he most often showed his dancers at practice or in repose and seldom painted actual performances.

The Museum's pastel, which is thought to have been executed about 1882, includes a dancer and an older woman dressed in black, holding an umbrella. Tradition has it that the subject was a young dancer from the provinces who was waiting with her mother for an audition. Degas sometimes included instructors or musicians in his works to act as foils to the more colorful dancers; placing the rather severe figure of the older woman next to a young dancer rubbing her sore ankle is a variation of this practice. It also emphasizes the discrepancy between glamour and artifice of the stage and the drabness of everyday life. Degas's continued preoccupation with the colorful and graceful, however, separates him from the realist tradition of Courbet and Manet (see no. 41).

BF

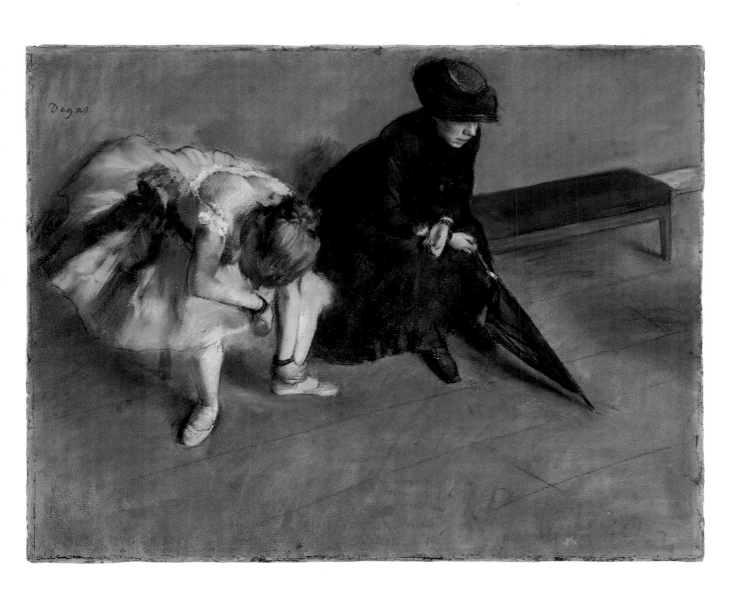

JEAN-ETIENNE LIOTARD

SWISS, 1702–1789

Portrait of Maria Frederike van Reede-Athlone at Seven Years of Age, 1755–1756

PASTEL ON VELLUM

53.3 × 43 cm (21 × 17 in.)

At top right, signed *peint par/J E Liotard/1755 & 1756*

83.PC.273

It was during the eighteenth century that portraiture reached its most refined and cultivated state. The number of artists whose chief occupation was the painting of likenesses increased, and their subjects began to include members of the burgeoning middle class as well as royal and aristocratic patrons.

Born in Geneva, Liotard was trained in Paris, spent time in Rome, traveled with English friends to Constantinople, and then worked for varying lengths of time in Vienna, London, Holland, Paris, and Lyons, generally returning home to Switzerland in between his stays abroad. As his popularity spread, his sitters often came to him, but he remained one of the best-traveled figures of his time. Liotard was a very idiosyncratic artist whose personal habits and dress were unorthodox; he sometimes sported a long beard and wore Turkish costume. His highly individual life-style was reflected in his work and sets it apart from that of his contemporaries.

In his writings, Liotard insisted that painting should adhere strictly to what could be seen with the eyes and employ the least possible embellishment. Most of his portraits depict royal sitters or members of the aristocracy rendered sympathetically and without pomp or elaborate trappings. The backgrounds are simple or nonexistent, and the sitters often look away as if they were not posing.

The *Portrait of Maria Frederike van Reede-Athlone* was painted in pastels, Liotard's favored medium, between 1755 and 1756, when the artist was working in the Netherlands. Initially, he painted a portrait of the young girl's mother, the baroness van Reede, who then commissioned that of her daughter. Maria Frederike, just seven years old at the time, is shown dressed in a winter cape of blue velvet trimmed with ermine; she holds a black lap dog, which stares directly at the viewer. The girl's pretty features and fresh complexion make this one of the most endearing of the artist's portraits. One also sees here the range and spontaneity that Liotard was able to bring to the use of pastels.

BF

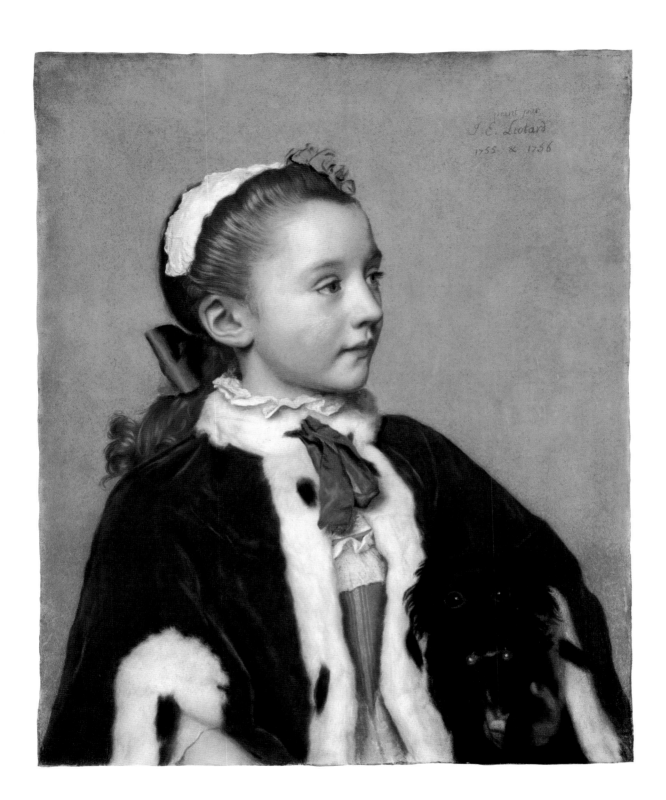

THOMAS GAINSBOROUGH

44

ENGLISH, 1727–1788
Portrait of James Christie, 1778
OIL ON CANVAS
126 × 102 cm (49 ⅝ × 40 ⅛ in.)
70.PA.16

In the eighteenth century, as today, London was the center of the international art trade. The English at that time were, and remained for the next century, the most avid collectors of pictures from all the major schools—Italy, France, Holland, Flanders, and Spain. Public museums did not yet exist, and except for a few private collections to which one might gain entry upon request, auction houses were one of the few places where a large number of artworks were regularly available for viewing. The auctioneer's role in the London art world was therefore considerable.

James Christie (1730–1803) was the founder of the London auction house that continues to bear his name. He began his career as an auctioneer in 1762 and within a very few years had made his firm into the most important and successful in Europe. An impressive figure, tall and dignified, Christie was on good terms with a wide range of society, including painters as well as aristocrats.

Christie's auction rooms were next door to the studio of his friend Thomas Gainsborough, who at that time was one of the most famous portrait and landscape painters in England. Gainsborough moved in the same circles that Christie did and was often commissioned to paint portraits of the collectors who frequented the auction salesrooms. The artist's affable personality was much appreciated, and it was said that his presence at Christie's sales contributed to the auctioneer's immense success.

Christie may have asked Gainsborough to paint his portrait in 1778, the year it was exhibited at the Royal Academy. Until the twentieth century, the portrait hung in the auctioneer's salesrooms. The subject is shown leaning on a landscape painting that is clearly in the style of Gainsborough, and he holds a paper in his right hand, perhaps a list of items to be auctioned. The very fluid brushwork and the ease and grace of the pose that invariably flatter the subject are characteristic of Gainsborough's portraits.

BF

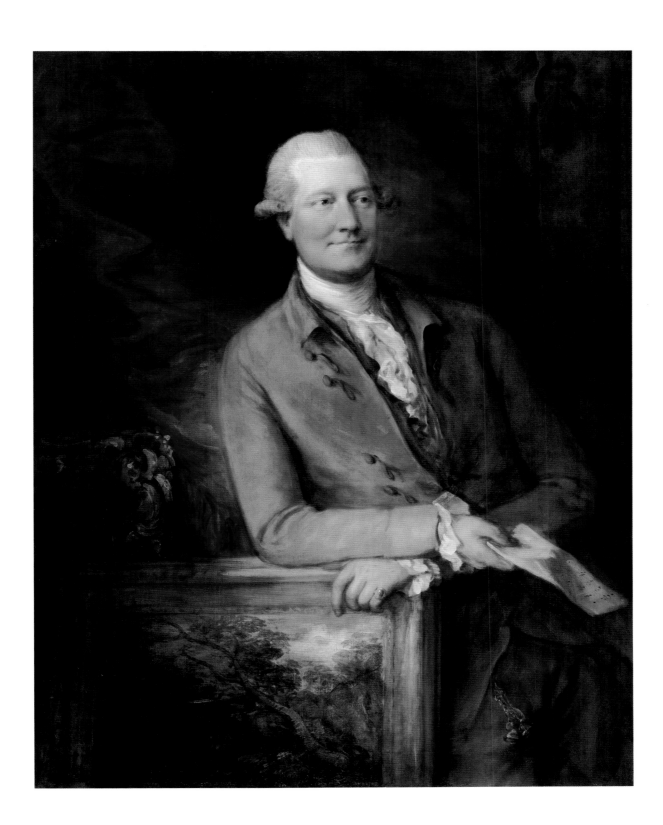

FRANCISCO JOSÉ DE GOYA Y LUCIENTES

45

SPANISH, 1746–1828
Bullfight, Suerte de Varas, 1824
OIL ON CANVAS
52 × 62 cm (19 ¾ × 23 ⅞ in.)
93.PA.1

The widespread censorship and oppression that followed the reinstatement of Ferdinand VII to the Spanish throne in 1823 caused many liberals to abandon Spain in voluntary exile. Francisco de Goya, the greatest Spanish painter of the period, left for France at age seventy-eight. An inscription on the back of the original canvas identifies the present work painted in Paris that summer as a gift for his friend and compatriot in exile, Joaquín María Ferrer.

The bullfight as an artistic subject was popularized by Goya and recurs throughout his career. A lifelong aficionado, he regularly attended bullfights and occasionally dressed as a matador himself. Goya's first serial treatment of the subject, a group of cabinet paintings dated to 1793–1794, employed a pastel rococo palette to describe the intricately costumed bullfighters and the elegant stands of spectators.

By 1816, when Goya published the thirty-three etched plates of the *Tauromaquia*, much had changed. Reinstated after a temporary ban, the sport was generally considered to be in a state of decline. Goya apparently shared this objection to the new abusive tactics; the plates of the *Tauromaquia* isolate the central figures of the drama and stress the integral aspects of cruelty and death.

The Getty *Bullfight* has great importance as Goya's final painted essay on this theme. Like the graphic work that largely occupied his time in his final years, *Suerte de Varas* exhibits a technical freedom and expressiveness typical of the artist's late style. For the most part, Goya's work in France took up earlier themes, reinvigorating them by pushing the limits of experimental technique.

The composition of the *Bullfight* is loosely based on no. 27 of the *Tauromaquia* series, which shows the celebrated picador Fernando del Toro on a blindfolded horse, drawing his pique on the halted bull. In the painted version, the blindfold has been removed and the faces of the bullfighters transformed into an anonymous tableau of fear and grim determination. The crowded stands in the background are indicated in an abbreviated gray wash. For the foreground drama, a spare palette of black, white, bright red, ocher, and turquoise, often in a roughly worked impasto, reinforces the contrast between the glittering costumes of the picadors and the vivid wounds of the gored and dying animals.

PS

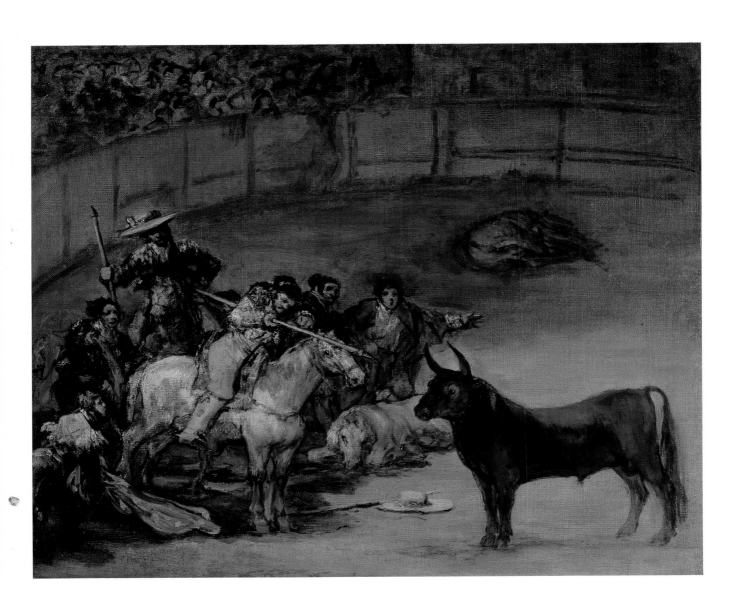

CASPAR DAVID FRIEDRICH

GERMAN, 1774–1840
A Walk at Dusk, circa 1832–1835
OIL ON CANVAS
33 × 43 cm (13 × 17 in.)
93.PA.14

A central figure in the German Romantic movement, Friedrich's deeply personal and intro-spective vision addressed Christian themes through analogies based on the cycles of nature. Although his work initially attracted a wide following, changes in fashion and patronage left him in poverty for his final years. Among the small group of works completed before a debil-itating stroke in 1835, *A Walk at Dusk* embodies both the melancholy of this period as well as the consolation he found in the Christian faith.

Unlike his contemporaries, Friedrich eschewed travel to Italy, finding his inspira-tion instead in the wide open spaces of his native Pomerania in the north of Germany. In the present work, a solitary figure—perhaps the artist himself—contemplates a megalithic tomb with its implicit message of death as a final end, a sentiment echoed by the barren forms of the two leafless trees that loom like specters behind the man and the grave. As a counterbalance, a second reading of hope and redemption is conveyed by the verdant grove in the distance and the waxing sickle moon, for Friedrich a symbol of divine light and Christ's promise of rebirth.

The megalithic tomb is a motif that recurs in Friedrich's oeuvre throughout his career. In their particular details, the tombs closely follow nature studies made of actual graves in the north of Germany. Yet, like all of Friedrich's major motifs, they become part of the artist's personal iconography and are recombined freely according to his inner vision. The configuration of rocks used in *A Walk at Dusk* corresponds closely to a drawing of a tomb made in 1802 near Gützkow on the island of Rügen, today in the Wallraf Richartz Museum in Cologne. The same study seems to have been used for an earlier painting, *Megalithic Tomb in the Snow*, in the Dresden Gemäldegalerie, which shows the tomb from a greater distance, dusted with snow, surrounded by a stand of once-impressive colossal oaks, now dead and broken. In the Getty canvas, a figure has been added to the landscape, not as a subject in the traditional sense, but more as a visual corollary to the contemplative state the artist sought to evoke in the viewer.

PS

JOSEPH MALLORD WILLIAM TURNER

47

ENGLISH, 1775–1851

Van Tromp, going about to please his Masters, Ships a Sea,
getting a Good Wetting, 1844

OIL ON CANVAS

91.4 × 121.9 cm (36 × 48 in.)

93.PA.32

A reverence for great artists of the past coexists in unlikely harmony throughout Turner's oeuvre with his celebrated technical experimentation. The present work, along with the other seapieces exhibited by Turner in 1844, his seventieth year, constituted the artist's final homage to the Dutch tradition. The seapiece held great meaning for Turner and his contemporaries both as an expression of the sublime in nature and as the symbolic arena of British ascendancy in trade and empire.

The Getty *Van Tromp* is the last in a series of four canvases depicting what seems to be an amalgam of two men, Admiral Maarten Harpertszoon Tromp (1598–1653) and his son Cornelis (1629–1691)—the "Van" being an erroneous addition which gained currency in eighteenth-century England. Both men earned renown for their naval victories against British and Spanish fleets during a period when Dutch seafaring power was on the rise. However, the precise historical episode depicted in the Getty *Van Tromp* has eluded definitive identification in spite of the lengthy title provided by the artist himself for the Royal Academy exhibition catalogue in 1844.

In the first of two possible subjects proposed by scholars, the Van Tromp represented would be the son, Cornelis, who was dismissed from service in 1666 after failing to follow orders, preferring to follow his own strategy. He was reinstated in service and reconciled with his superiors in 1673. Perhaps as a symbolic overture signaling his submission to authority, Tromp is shown "going about to please his Masters." He skillfully executes the manoeuvre while posed defiantly on the foredeck of his ship, braced against the heavy spray of breaking waves, luminous in his (ahistorical) white uniform.

The second suggestion has the protagonist as the father, Maarten Tromp, who, during the Anglo-Dutch war in 1652, led three hundred Dutch merchant ships through the English Channel and safely back to Dutch waters. Tromp was said to have tied a broom to his mast (visible in the painting) to symbolize sweeping the British from the seas.

With the representation of such historical narratives (their accuracy aside), Turner elevates the seascape to the pinnacle of prestige previously reserved for history painting. In the Getty *Van Tromp*, Turner expresses the sublime power of nature as seen by a Romantic painter through the lens of the Dutch seascape.

PS

JAMES ENSOR

BELGIAN, 1860–1949
Christ's Entry into Brussels in 1889, 1888
OIL ON CANVAS
252.5 × 430.5 cm (99 ½ × 169 ½ in.)
At right center, signed J. ENSOR/ 1888
87.PA.96

Caricature and societal critique are elevated to a high art form in James Ensor's monumental manifesto on the state of Belgian society and modern art in the later nineteenth century. Painted in 1888, *Christ's Entry into Brussels in 1889* sets the second coming of Christ in the Belgian capital one year hence. Aggressively insular in his artistic outlook, Ensor painted *Christ's Entry* partly in response to the critical success that had met French painter Georges Seurat's *Sunday Afternoon on the Island of the Grand Jatte*, when it was exhibited in Brussels the year before. He was angered as much by the cool, controlled Pointillist style pioneered by Seurat as by the Frenchman's conception of a placid, classless society blandly enjoying leisure-time diversions on the banks of the Seine.

By contrast, Ensor portrays contemporary society as a cacophanous, leering mob. In nightmarish fashion, elements of pre-Lent carnival and political demonstrations merge with Christ's procession. Threatening to trample the viewer, the crowd pours into the foreground, arranged in steep, wide-angle perspective. In the front, leading the festivities, is Emile Littré, the aetheist socialist reformer, clothed by Ensor in bishop's garb. The mayor stands on a stage to the right, dwarfed by his podium and surrounded by clowns. Jostled and overwhelmed, Christ numbly rides his donkey in the middle-ground, more an object of curiosity than of reverence. In the northern tradition of Bosch and Brueghel, an onlooker in the upper left leans over a balcony to vomit onto a banner marked with the insignia of *Les XX* (les Vingt), the Belgian avant-garde artists' association, which would ultimately reject this painting from its annual salon despite Ensor's status as a founding member. By giving him his own features, Ensor projects his own sufferings and aspirations onto the Passion of Christ.

Here, and throughout his oeuvre, Ensor finds means to express his horror at human depravity and vice in the imagery of skeletons and the carnival masks that would annually fill his mother's souvenir shop in the seaside resort town of Ostend. Joining them in this bizarre procession, public, historical, and allegorical figures commingle with members of the artist's immediate circle of family and friends. With its aggressive, painterly style and complex merging of the public with the deeply personal, *Christ's Entry* has long been heralded as a harbinger of twentieth-century Expressionism.

PS

LAWRENCE ALMA TADEMA

49

DUTCH/ENGLISH, 1836–1912

Spring, 1894

OIL ON CANVAS

178.4 × 80 cm (70 ½ × 31 ½ in.)

At bottom left, signed *L. ALMA TADEMA OP CCCXXVI*

72.PA.3

Sir Lawrence Alma Tadema was one of the most popular and successful painters of his time. Although his reputation has suffered as a result of the change in taste that favored Courbet and, later, the Impressionists (see nos. 39–42), his work still holds a fascination for us because of its extraordinarily meticulous technique.

The artist's style had its origins in seventeenth-century Dutch painting of everyday scenes, but the bulk of his work was dedicated to Greek or Roman subjects. Rather than the heroic or literary, however, the themes of his paintings are usually simple ones—to the modern eye even banal at times—chosen to represent daily existence in pre-Christian times. They also reflect Victorian sensibilities regarding social behavior. In the midst of the enormous economic upheaval and social discord the Industrial Revolution had brought to England, a segment of the upper class, to which Alma Tadema belonged, continued to look back to the classical past as a simpler, idealized time. His was probably the last generation to do so with such unequivocal admiration.

The Museum's painting is one of Alma Tadema's largest. He is known to have spent four years working on it, finishing in 1894, in time for the winter 1895 exhibition at the Royal Academy. Depicted is the Roman festival of Cerealia, which was dedicated to Ceres, the corn goddess. Although the edifice represented is essentially a product of the artist's imagination, he has incorporated portions of extant Roman buildings, and the inscriptions and reliefs can be traced to antique sources, reflecting the artist's profound interest in classical civilization and architectural detail. The painting still bears its original frame, inscribed with a poem by Alma Tadema's friend Algernon Charles Swinburne; it reveals a particularly idyllic view of Rome: "In a land of clear colours and stories / In a region of shadowless hours / Where the earth has a garment of glories / And a murmur of musical flowers." *Spring* was an enormous popular success, and its fame spread to a wide audience via many commercial prints and reproductions.

BF

EDVARD MUNCH

50

NORWEGIAN, 1863–1944
Starry Night, 1893
OIL ON CANVAS
135 × 140 cm (53 ⅜ × 55 ⅛ in.)
At bottom left, signed *E Munch*
84.PA.681

Edvard Munch stands between the Romantic painters of the early nineteenth century and the early twentieth-century Expressionists. His work evokes the brooding quality and psychological isolation of the Romantic spirit combined with a stark, almost primitive directness of execution, which anticipates the comparatively uninhibited individualism of our own century.

Starry Night, a depiction of a coastal scene, is one of the few pure landscapes the artist painted in the 1890s. It was executed in 1893 at Åsgårdstrand, a small beach resort south of Oslo. Munch spent his summers there and often included one or more of the town's prominent landmarks in his pictures. In spite of the fact that this was a place of relaxation and pleasure, Munch's paintings of it often suggest personal anxieties and sometimes even terror.

Because the Museum's painting does not include figures or the town's pier—which would have been just off to the left—it has a more abstract quality than usual and an ambiguous sense of scale. It is an attempt to capture the emotions called forth by the night rather than to record its picturesque qualities. The mound at the right represents three trees. The vaguely defined shape on the fence in the foreground is thought to be a shadow, probably that of two lovers who are placed in the same setting in a lithograph of 1896. The white line before the clump of trees, which parallels the reflections of the stars on the sea, may be a flagpole, but it seems more like some natural phenomenon, such as a flash of light.

Munch's *Starry Night* was included in a series of exhibitions held between 1894 and 1902, each time with a different title. It was referred to as *Mysticism* or *Mysticism of a Starry Night* on occasion and was part of a group called Studies for a Mood-Series: "Love." Later it seems to have been included in the artist's 1902 Berlin exhibition as part of the same series, now called Frieze of Life. This group of paintings was a very personal, philosophical commentary on man and his fate and was imbued with religious overtones.

BF

ving list references entry numbers, not page

Dagmar Grimm, Editor
Kurt Hauser, Designer
Elizabeth Burke Kahn, Production Coordinator
Charles Passela, Louis Meluso, Photographers

Typography by G&S Typesetters
Printed by Arizona Litho